Profile 23 – DAPHNE WRIGHT

Profile 23 – DAPHNE WRIGHT

Published as part of Gandon Editions' PROFILES series on Irish artists (details, page 82).

ISBN 0948037 261

Editor John O'Regan

Asst Editor Nicola Dearey
Design John O'Regan
 (© Gandon Editions, 2006)
Production Nicola Dearey
 Gunther Berkus
Photography see page 78
Printing Nicholson & Bass, Belfast

Distributed by Gandon and its overseas agents

GANDON EDITIONS
Oysterhaven, Kinsale, Co Cork, Ireland

tel +353 (0)21-4770830
fax +353 (0)21-4770755
e-mail gandon@eircom.net
web-site www.gandon-editions.com

cover *Indeed, Indeed*, 1998

Gandon Editions is grant-aided by
The Arts Council /
An Chomhairle Ealaíon

contents

Published to coincide with the exhibition at
Limerick City Gallery of Art
(20 January – 26 February 2006)

LIMERICK CITY GALLERY OF ART
Pery Square, Limerick

tel +353 (0)61-310633
fax +353 (0)61-310228
e-mail lcgartzz@iol.ie
web-site www.limerickcity.ie/LCGA

Director Mike Fitzpatrick

LCGA
LIMERICK CITY
GALLERY OF ART

Daphne Wright is represented by

FRITH STREET GALLERY
59-60 Frith Street, London, W1D 3JJ

tel +44 (0)20 7494 1550
fax +44 (0)20 7287 3733
web-site www.frithstreetgallery.com

Frith Street Gallery

Profile Daphne Wright

GANDON EDITIONS

709.0507
W9310r

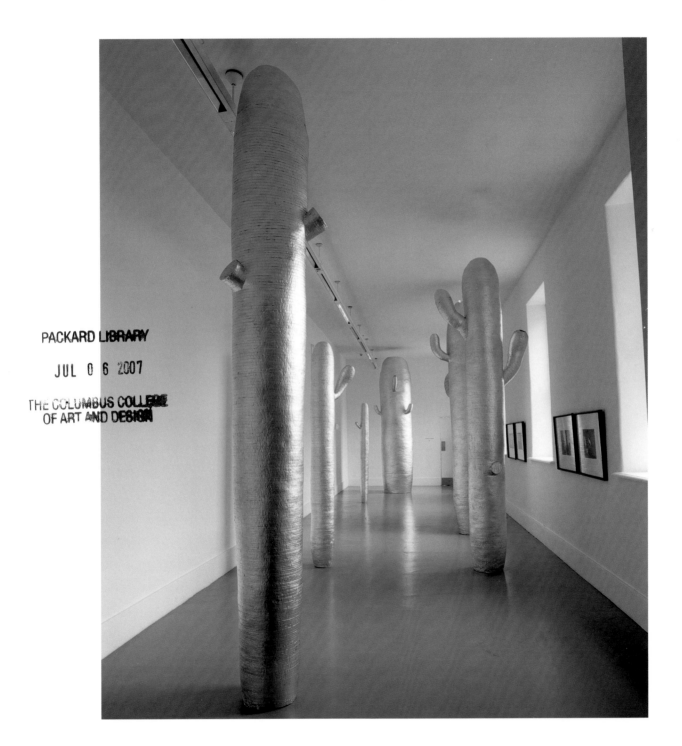

Spaces
of the mind

PENELOPE CURTIS

This was what had occurred, that their lesson had been learned; and what Mrs A had dwelt upon was that without Charlotte it would have been learned but half. It would certainly not have been taught by Mrs R and the Miss Ls if these ladies had remained with them as long as at one time had seemed probable. Charlotte's light intervention had thus become a cause, operating covertly but none the less actively, and Fanny A's speech, which she had followed up a little, echoed within him, fairly to startle him, as the indication of something irresistible. He could see now how this superior force had worked, and he fairly liked to recover the sight – little harm as he dreamed of doing, little ill as he dreamed of wishing ... She had been so vague and quiet about it, wonderful Charlotte, that he hadn't known what was happening – happening, that is, as a result of her influence. 'Their fires, as they felt her, turned to smoke,' Mrs A remarked; which he was to reflect on indeed even while they strolled.

HOW DO WE REMEMBER BOOKS? SOME PEOPLE REMEMBER STORY LINES AND DETAILS, BUT FOR OTHERS these facts fade away within hours of putting the book down. Do those of us who love reading, but who never even remember the proper names of the characters, share similar experiences of a given book? How can we compare our experiences if we can hardly describe them?

Such experiences are pluralistic and enduring, as if made up of distant rooms in an enormous castle, with routes that are only occasionally accessible, and doors that are only occasionally unlocked. These are spaces of the mind, with borders that overlap

Where do broken hearts go?
2000, cacti, tin foil, glue, resin, continuous loop tape, series of 9 intaglio plates (collection: Irish Museum of Modern Art)

with those of other people, but with substantial areas of semi-darkness which seem to be entirely personal. They are spaces which we don't try to and don't want to explain or elucidate. They are both shapely and shapeless. They create an atmosphere that only becomes characteristic with successive encounters, like a walk, or a house, that can only be described in its own terms. Or like an author, whose aura we come to know and seek out in another book so that we can regain their space one more time. Like a book by Edith Wharton; like a book by Henry James.

Such particular atmospheres are brought to mind on occasion, and the best we do to describe the process is to evoke Proust. Whereas he, an author, grappled with the form of his own memories, we, more lazily, may use his novel to describe our experience of reading other novels and having them returned to us, unexpectedly. So, though I understand that I might remember an artwork in the way I remember a book (or an author), I wonder if this will help me to describe it?

———

When Daphne Wright was a student she followed the work of Robert Wilson, the artist, theatre director and designer, and now, looking back on about fifteen years of her work, there is a sense of a largely structured drama unfolding act by act. The long view is clear enough, as if set in separate pools of light, but the close-up view is more tangled, as her characters seem enmeshed in a complicated script.

The acts have their own titles and are clearly set in different materials, their theme echoing their making. At the time of the initial staging their meaning is not clearly grasped by the artist, but when it becomes fully understood, she puts it behind her, developing a new theme at first, and then, more slowly, a new language. After the media of plaster and tin foil came film, and now papier mâché.

Wright works on the border between things being ugly and attractive, inchoate and 'choate'. The very amateurishness of some of her making – using wet and formless materials – allows her to occupy this indeterminate threshold. Once the works become sufficiently presentable (i.e. neither too ugly nor too embarrassing), she shows them. But once she has mastered her material, she abandons it. Her struggle with unmade materials echoes each new struggle with a theme, and finding the language to suit it. Shaping plaster or foil is an activity somewhat akin to learning to speak, finding the sounds and practising the syntax. When she speaks, as it were, in her new language, she speaks haltingly, as if testing her ability. Once she is fluent, she stops speaking. Thus we need to be ready to accept the child-like utterances as fully intentional.

As a child, Wright read a good deal. As a student, she took herself off to be diagnosed dyslexic. Wright's current understanding of language seems to be pinned between literacy and illiteracy. She was deeply formed by the experience and spaces of literature, but now allies her comprehension of language with that of the dyslexic, which she understands as peculiarly three-dimensional.

Wright's world is certainly a complex one, and one, moreover, which seems to be a combination of a ready naïveté with an unwonted sophistry. The juvenile materials, the retreat into the inner world, the obsessive and repetitive-making are not too distant from a kind of autism. Wright herself describes the foil as an autistic language, and it is tempting to take the analogy further, and to make a connection with her dyslexia. But, at the same time, Wright's playing out of her inner grasp of language is challenging and sufficiently convincing to reach forward and pull the reader in. Fundamental to an understanding of Wright's usage is that language is not necessarily about communication. It might be as much about disguising or avoiding the subject as about expressing it.

Most of Wright's installations (or might we call them sets?) are accompanied by sound. Sound comes to reverberate as something which has escaped the restraint of the material: sounding, fragmented, but apparently authentic. How it works alongside the visual language is not entirely clear to me – as reinforcing or undermining? At any rate, though the sound may run in paral-

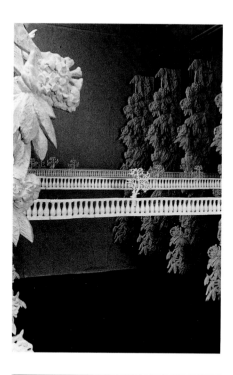

Lot's Wife I
1995

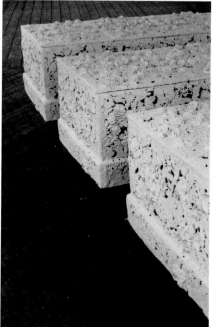

The Tombs
1995

lel, it undertakes no task of completion, but, on the contrary, reinforces the hybrid nature of the work as a whole. When Wright's material structures are almost prison-like – in overall form and in material detail – the songs and voices seem subversive and freer. They also add body to compositions which might be largely graphic, providing the life for scores or for screens which need animation.

I am suggesting that we are readers, rather than spectators, of Daphne Wright's work. This is not just because of its parallels with the spaces of literature, but also because of its linearity and multiplicity. To some extent Wright sees this as a failing, meaning that she describes her work as 'incomplete' and 'unsatisfactory', while at the same time enjoying this failure to add up. By incomplete she means un-pictorial, and judges, moreover, that this is a trait which makes a link with a number of other artists who show with her and whose work is similarly 'not whole'. She includes Jaki Irvine and Mike Nelson in this grouping. They inhabit the spaces of literature; they can be written about better than seen. As I paraphrase, I doubt. I am testing the very likelihood of Wright's assertion that writing suits this art. And if writing were really more effective, then I wouldn't be writing about it at all.

———

Daphne Wright seems to remember books in much the same way as I do – as places, with atmospheres and feelings, but without proper names. So I don't know how much, if anything, this has got to do with dyslexia. But she also seems to remember them as places of deception. Lies feature surprisingly strongly in Wright's work, and the layering of a novelist like Henry James, which engages and then rejects successive potential interpretation, reverberates throughout. The materials she has chosen have no 'inner truth' of their own. They are adaptive, reproductive, chameleon or even parasite-like. They cling to other forms, adopt their shapes, and copy them. The plaster she saw as smothering or muffling; the foil as communicating in a manner of which it 'itself' is unaware. Presenting an apparently sure exterior, it holds its own secrets inside, unaware of or unconcerned with the outside world.

Daphne Wright read because she was bored with looking. In the wide open countryside she either resorted to looking for detail, or she immersed herself in the still wider landscape of the 19th-century novel. The dominant memory of her childhood, and beyond, is that of boredom. So what did she take from her reading and what was the nature of its truth? Did the books affect her or not? Why is she interested (indeed, why does she believe) in the semblance of affect in the place of real emotion? Did she read her books with this in mind: that the emotion they created was inauthentic? Why does she believe, and want to believe, that her own works offer no more than (and as much as) this? If she is keen to show that beauty and ugliness – take what you will – mean the same and nothing, she is on dangerous ground. Wright's answer lies in the effect of affect: the point at which the viewer/reader understands the artifice and thereby experiences a change in emotional register.

As Wright has got older she has learnt to make less herself, and to get other people to make more things for her. She has also taken a step away from the compulsiveness that confuses hard work with self-help. This growing up and away is not entirely convincing, however. Pleased to have put distance between herself and the Anglo-Saxon work ethic, she nevertheless misses the making (even if getting better at making something didn't necessarily equate with or could even disguise artistic and intellectual development). Now she makes drawings instead, which isn't so satisfying. And if she isn't bored now, it's only because she hasn't got time. So boredom seems to have been the very necessary prelude to being impelled to make something different to look at. It takes a long time to make something really different, or otherwise things simply look like other things that have already been made. Only boredom could engender something properly dissimilar.

Wright doesn't seem to have liked people feeling any sense of ownership of her earlier plaster works, because they were all about her own past. But more recently she has been actively engaged with exploring what ownership does to meaning, and how it can affect both how her objects are made, and how they are understood. Her circle of operations has expanded and she is ready to use others as interpreters and makers. This is not just

Croon
2004
collaboration with
Johnny Hanrahan

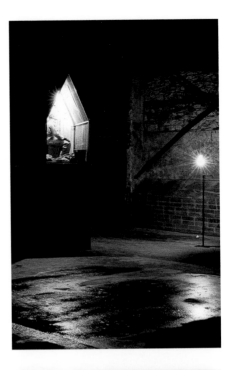

about making more 'public' or permanent art commissions – for this has been going on for a while now – but more about using other people to answer the same questions as she had been setting herself. Wright sees herself as a largely dispassionate observer, identifying similar symptoms in apparently different circumstances. This leads her to present her results, in seemingly disjunctive juxtapositions, across, for example, the human and animal worlds. Bringing urban and rural together, in space and time, is a concern which Wright posits firmly (even polemically) in the present, even if her urban viewers may associate it with the past. Using source objects (which she has had interpreted and fabricated by others, and then offered to and interpreted by a range of new owners) takes Wright a long way from inventing and describing her own forms in plaster or foil. Change is in the air.

None of the eight acts of the play so far has any ending. I doubt there will be any conclusion. But by knowing the literary or dramatic spaces which Wright's sculptures inhabit, I find myself less bothered by the peculiarity of their making. I am not quite sure why seeing them as sets or as chapters removes this anxiety, but it does. It helps me to understand that it would be wrong to look for 'authenticity' in Wright's work in any kind of simple (and above all biographical) way. If the spaces of literature are full of dissemblance, we must allow visual art to be similarly untruthful. This also helps me to re-read the way Wright makes things. There has always been something worrying about work which smacks too much of the obsessive, as Wright's has, on occasion, in the past. But it is of course the obsessiveness which has made it remarkable. And obsessiveness may conceal, or at least not reveal.

How will Wright now develop her particular voice while at the same time opening up her work to the reader and allowing us into her space? As she moves from the extremely tangible – her extensive and carefully fabricated installations – towards the immaterial world of film, it will be interesting to monitor how her works come to compare to those of Jaki Irvine. Being two-dimensional (or graphic), Irvine's works are much closer to the deep space of the page than those of Wright, which have always spoken in (and been bounded by) the more defined spa-tial terms of material, floors and walls. Alongside Irvine, Wright has also cited Mike Nelson as an artist to whom she feels an affinity, and his work too, though also related to storytelling, is remembered as a concrete physical experience. Does Nelson most nearly represent an artist who creates physical spaces which are nevertheless remembered like those of a novel? By moving away from making, and towards thin image and sound, Wright may be sloughing off the physical and entering more securely into the remoter spaces of memory. Her work may lose its distinctive personal touch, but it may also engage more people, because the space (or the non-space) and the material will be common. Wright hovers on this threshold, wondering whether a more common language equates in any real way with success, and is loathe to leave behind the possibility that sculpture (the stuff itself) has an existence beyond the physical, and one that is as layered as literature or memory itself.

Penelope Curtis is curator of the Henry Moore Institute in Leeds where she runs a programme devoted to historic and contemporary sculpture. She researches and publishes on sculpture in inter-war Europe, as well as working with and writing on contemporary artists.

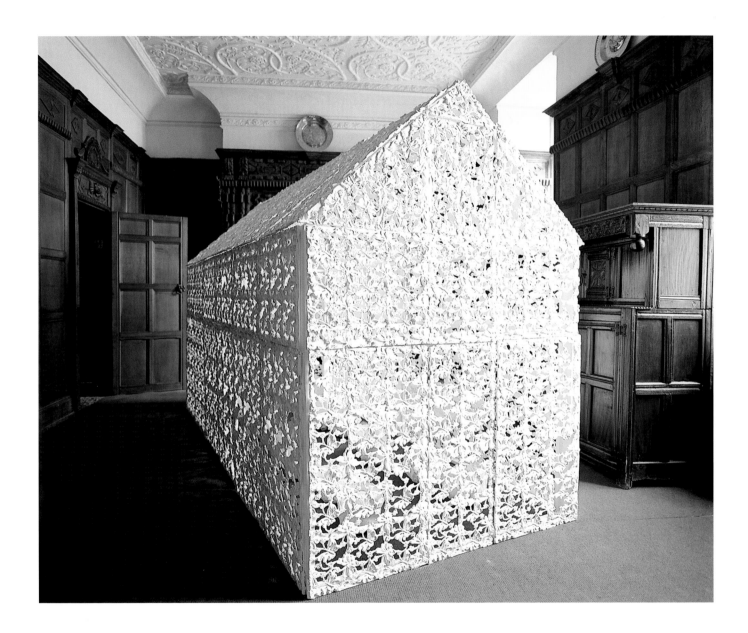

A Conversation with the Artist

SIMON MORRISSEY

Simon Morrissey – In the beginning, the fact that you are from a southern Irish Protestant background meant issues of identity became a dominant reference in the discussion of your work. It was a discourse that you felt came to obscure the wider meanings within your work. Were there specific experiences in your background that have fed into the themes and concerns that populate your work?

Daphne Wright – I think that our background left us with the feeling that we were separate and that we had to remain separate from the majority, and ideas of separation and remove are important within the work. But I suppose I have tried not to talk about those ideas in my work because they are present in much more universal terms.

The fact that your work is often populated by an Irish voice through a soundtrack may provide some idea of cultural identity. It is evident that the voices are not characters but articulations of ideas, embodied in such a way as to manufacture a psychological space for the viewer, to give a particular emotional tone to the work.

I think they are really emotional, but they achieve this by displaying no emotion. The

Still LIfe: The Greenhouse
1995, plaster, 305 x 152 x 198 cm
(installation at Bowes Museum)

way I work with the speakers I use is really important in relation to this. The first take is the one I always use. I give the person the text to read, and as they haven't seen it before, it is being revealed to them as they read, and they don't have an opportunity to invest anything into it. That is really important for a work such as *Where do broken hearts go?*. When the woman was reading it her brain was ahead of her mouth, and that gap between the thought process and what is spoken is really important.

Because that produces a certain awkwardness...

I think it leaves a gap, and that gap then creates the gap for the viewer. So it's this thing that's never solved, it's never complete. And because you leave a gap, the audience can fill it rather than having it filled in for them. For example, with *Where do broken hearts go?*, by the time the speaker had read the text a number of times she became really emotionally involved in it. Those takes had to be rejected because they were quite distressing to listen to, and that really affected the work. You couldn't really look at the tin-foil sculptures with any detachment because the emotion of the text disrupted the surface. There was no gap; it just layered on top of it.

What I am trying to achieve is the quality of bad animation or of poorly dubbed films, where you see the mouth moving but the voice is in a different place. I find that a really compulsive condition. I suppose that's how I look at the relationship between the sculpture and the voice. You have a sculpture before you but the mouth is in the wrong place; the voice has gone in another direction. I find that a very poignant place to position the work and the viewer.

Where do the texts come from? Are the words in that piece from country and western songs?

Yes. They are taken from three songs. One is about a child murder, one is about a gun battle, and one is about a broken heart. They are the three typical country and western themes. Country and western songs are full of elaborate storytelling and awash with sentimentality, but beneath this there is an attempt to tackle the human condition, and often its darker sides. I think that is the common ground between all the sounds I use. I am drawn to sources from common culture – from popular culture or folk culture – that at first seem whimsical or sentimental or nonsensical, but are actually mining something serious that reveals itself more slowly. I have used some form of imitation, such as ideas of mimicry or ventriloquism, to remove the sounds from their original context and allow the darker psychological tones in the source material to emerge.

As well as country and western songs I have used limericks and children's circular rhymes. In *Nonsense and Death* I used limericks by Edward Lear, all of which were about old men. Although at first the nonsensical form might suggest the humour of old men's eccentricities, it also suggests the idea of the old losing their senses at the end of their lives. I was interested in the idea of whether nonsense could become more sense than sense, and more poignant. In *Indeed Indeed* I used a circular rhyme. I was really interested in whether the fact that it begins where it ends could create the idea of slipping from consciousness into unconsciousness and back again, of being in a limbo state that was never broken.

I don't think the importance of the spoken texts can be emphasised enough. Unless you have experienced the sound element of your works, you get a completely misleading impression of how they function.

I think the majority of people only see the work through photographs as the installations are only on for a certain amount of time, so there is definitely constant misinterpretation of the work because of this. But I find that really fascinating because it almost mirrors the gap that I am trying to make in the work between the sculpture and the voice and the prints, for example. In a way, the work sort of shoots itself in the foot, but there is a strange pleasure in that. I think I do take a pleasure in the work being 'misunderstood'.

What motivates that pleasure?

I think some of it is about an interest in deception and how

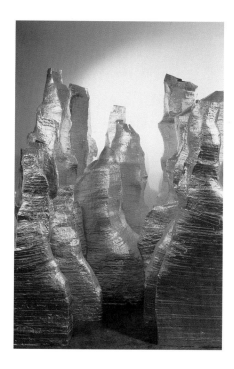

Indeed Indeed
1998

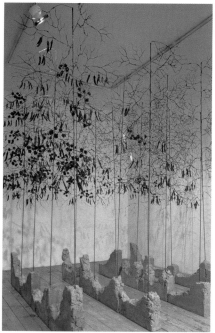

*Nonsense
and Death*
1998

honesty is assumed in things that come to the surface and are seen first off. I think all through the work I have been interested in falseness and pretence, and they are used through theatrical devices and pictorial devices, using foregrounds and backgrounds, behinds and fronts. And in a way, sound and sculpture often work on exactly the same lines as the pictorial view.

Is the interest in deception, falseness and pretence an interest in suggesting that things are often different to how they first appear?

I think I've always been interested in the idea of things and people being underestimated, and that's led to an interest in revealing that something might have been underestimated in the work. I also think there is more of a lasting value or resonance in things that reveal themselves slowly. For me, it is really important that we might have to realise that we have been wrong about something, to have to change our point of view half way through assessing something, then continually reassess it the more we engage with it. It's about the way we look at things being linked to the way we judge things.

So do you think when people see the work they impose a hierarchy on what is the most important part of the piece of work? Do you think they see it as 'sculpture' with some sound? Do you think of it in that way to?

Because the sculpture is so physical, it definitely takes over the space and demands the viewer's attention. I think I see the sound as something that moves around the sculpture. I think I have said before that I use the sound to subvert or conceal, and I think that is still the way I view it. The sound is like something being put under your nail or rubbing on your skin.

So more like an agitation?

Yes, to agitate and to expand them. There is a certain frustration with something being permanent and static, so by using the narratives in the sound you expand the dialogue for the piece and you also create subtly different scenes. I think the prints also function in that way. All of the elements are differ-

ent, yet there is a common condition that they occupy together. Without that layering the objects just look like stupid sculptures of cactuses or spaceships!

There are elements of your work that suggest particular values. It is quite evident to the viewer that all the sculptures have been laboriously and meticulously crafted. The assumption that tends to accompany that level of physical investment is that the artist is particularly interested in exploring the quality of materials as an end in itself. Does your engagement with material relate to the ideas of deception you mentioned earlier?

People have always commented on how crafted the work is, and there is something almost derogatory in that observation. Initially I think I was offended by that, but then I began to quite enjoy it. People have parameters that they associate with well-crafted work, and often it is that that kind of artist who investigates through material is intuitive rather than conceptual. That was definitely the way it was thought about during my education. With the early plaster work I sickened myself with the craft of it, but I think I have become increasingly interested in messing up those parameters or expectations. There is something compulsive about taking a material to such a point that you torture it. Once you've done that, you understand a material.

I think I do that with all the materials I work with. I see them as a kind of a voice. They have a sound and a language, and once I have exhausted that language I move on from it. I think the obsession I have with a material for a particular time is the same as the obsession with the things that might be the subjects of the work, like Russian spaceships or country and western songs. They are just ingredients. The quality of a material is just the same as the quality of a sound. I don't see any difference between the sound of a voice or the 'sound' of a material.

Does that explain why your body of work divides into segmented, conversational groupings? Is it another conscious way of producing the gaps you have talked about within the work?

I'm not sure if it is as planned as that. I think frustrations build up with ways of working, and as your ideas evolve those ways

The Pretender
1994

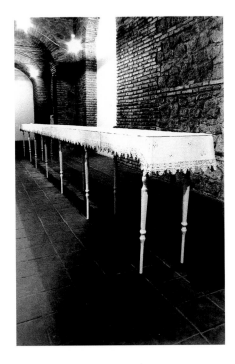

Death Mask, Horace
2003

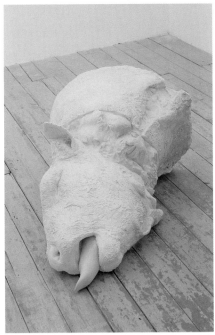

of working seem limited. I began to realise I was really interested in falseness. The decision to work with tin-foil partly came about because it seemed such a physically deceptive material, and then there was the feeling that it had an almost autistic quality. This, mixed with the feeling that the plaster was too familiar, too eloquent, too historical a material. The viewer could understand it too easily. It gave the viewer too much too quickly. And it was always commented on how beautiful the plaster was, and I thought that working with something that is beautiful produces beauty in a mean way. The tin-foil is a more complex material, yet it is also inadequate, which seemed to match the inadequacy that I wanted in the voices.

There are different ideas of isolation and remove woven throughout the work. These ideas are expressed as both human conditions and as formal structures in the work. The conjunctive structures in the work are deliberately excised and sensations of loneliness, human isolation, aging or even death are evoked.

There is definitely a tone that runs through the work that relates to those ideas, but I wonder if trying to name it as any one theme is too much of a pat solution to the whole thing. I think it relates to the lack of continuity in the work. I don't think continuity is the way human beings work at all. I think we muddle through things, and I think a lot of my work is like that. I don't know if that muddling ends up with some clear prominent themes or repeats, which come out again and again, or whether we just want to find that. I don't understand artists who begin in one place and end in the same place years later. I think it is much more to do with exhausting your curiosity in a given thing. It is about a mind that moves around and isn't content with one vein of focus. You get bored and you ask yourself 'is this what I am going to do for the rest of my life?' And then you change. It can be simple like that. The more sophisticated you become in manipulating a material the less appeal it holds. You become suspicious of your motivation for continuing to churn work out.

Is that how you moved from tin-foil spaceships and country and western songs to making life-casts of severed bull's heads and stillborn cattle?

To some degree, yes. And I also think its was because I had a child. That had a huge impact on me. I don't think art is some alien thing that is removed from your life, but that the interests and concerns in art and life mirror each other. I began to look at breeding and reproduction, and became really interested in it. I found myself getting obsessed with the breeding of cattle, and at the same time looking at the idea of the severed head – at John the Baptist's severed head, myths about severed heads, and why the head decapitated is such a powerful image. This mixed together with the idea of the patriarch, the 'head' of the human family. I grew up on a farm where they breed cattle, and I go back there a lot. I got obsessed with the idea of a dead bull's head. I spent a year on the telephone trying to get a dead bull to cast; that was incredibly difficult. I became very involved with the industry in order to secure the bull, and I began to note how emotionally invested the families who own the bulls become in the animal's reproductive life. In a way I think that is very similar to what was going on in the previous work, in that it is about human dynamics.

The way the work is permeated by a sense of disjunction, however, would suggest that it is the failure or failings of those dynamics that you are most interested in.

I wouldn't say failure, because it's never as simple as that really. It's more to do with our constant attempt to resolve these dynamics and the fact that we are often not capable of doing so. There is something quite pathetic about the feebleness of our attempts at resolution set against our continual desire for it.

It strikes me that what we are establishing through relating the works to each other is that the surface content of the work is not really what the work is about. In fact, they are a sort of cipher for the subject of the work. That introduces a gap between the expected reaction to the work and the reaction the viewer is permitted by it. We expect to have a visceral reaction when encountering a life cast of a dead animal, but the work does not permit us that reaction because the material and the lack of colour have leached the death out of the animals and ossified them, again creating a remove. You seem to b performing the same manoeuvre time and time again in the work, but

continually looking for new ways to perform it.

I think you are able to get that perspective as you move away from a group of works. When you are making it, the primary interest is in the investigation that the work performs not how it turns out, because a lot of the time I just find the way it turns out unsatisfactory. When I made the life casts I couldn't tell whether they were successful or not, precisely because of their emotional detachment. They also felt like a complete hiccup in the journey that the work had been making up to that point. The fact that the work was predominantly framed in relation to recent crises in farming, like the foot and mouth outbreak in Britain, also forced the work into a cul-de-sac for me for a while.

I think before you said my work seemed to fit into conversational groups, and that is becoming true of the work with the bulls. I think my interest in animals is only in the way they can reflect back on the human. Over the past year I have been doing research into the status of certain animals in zoos. There are certain animals that develop particular relationships with the zoo-going public because they live for a particularly long time or have certain characteristics. These animals have almost human personalities attributed to them. For example, there is a very old elephant in Belfast Zoo, or an albino gorilla called Snowflake in Spain. There is such a peculiarly sentimental conundrum in the idea of an animal being kept in captivity by humans, then acquiring human attributes. The life-casting has become one possible way of working, and animals have become one area of investigation, but I couldn't ever imagine any particular area of interest, or way of making work, becoming the only way I work.

Is that about the inability of any one thing in the world to be significant enough to be the only host or site to investigate the disruption of expected relationships?

Or maybe of any concern. I think it's the shifting nature of thought. It's human curiosity. At the time, the thing you are fascinated with is all encompassing, you can't see anything else other than that. And then, as soon as its done, it is gone and you have no interest. You use a subject and then you move on. I don't understand why you would want to go over the subject again. You have mined the ground. You have looked at something so carefully there is nothing left to look at. Its spent and there is nothing of value to be gotten out of it. People might think that to say you 'use' an animal and then it is spent is wrong, but it is only the head of a dead animal – no different to the position the animal has in husbandry, its normal life.

Is that reaction to do with confusion between sentiment and sentimentality?

I really enjoy sentimentality, nostalgia, romance. I enjoy the notion of them, and the fact that people feel you shouldn't have regard for them because they are a kind of low culture. There is something about being attracted to them because you are not meant to be. I enjoy the fact that people might see the work as embarrassing for dealing with these things. I think the division between high and low culture is that one is about controlled emotion and the other is about uncontrolled emotion. I'm interested in people's fear that something might maraud out of its set place. Lots of artists use these things as material, but I think if you do use them and then hold them back or remove them, they can achieve a real power. It's like the idea of beauty. You can use beauty to seduce, but then twist it into something most horrifying by a subtle tuning backwards. If you are explicit with an idea it's all there on display to be absorbed and taken away, which makes it less dangerous, less effective.

Your recent public project in Glasgow seems to underline the place embarrassment and expectation has in your work.

The work is called *Home Ornaments*, and was made for a new social housing development in the Gorbals. There are 127 apartments, and each person that moves into an apartment will be given an object. They are free to look after it, throw it away, hide it in the cupboard, or swap it with someone else in the apartment block. Partly it is concerned with community relationships and how people might interact around the work, and whether it might add anything to their community. The objects are all highly crafted by professional makers, so there is the idea of skilled manufacture that runs through my work. They all arise

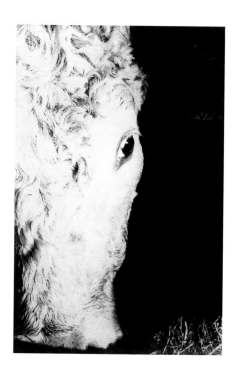

Bulls – Joe
2002

from certain histories or stories that emerged from the area. There is a model of the original block of flats designed by Basil Spence, modelled in fake plastic ivory; a black and white print of an orang-utan in an ornate plaster frame; an embroidered parrot; a knitted cactus; and a ceramic cast of a taxidermy guinea pig decorated to look like a Wedgewood figurine.

What I wanted to do was create and place a series of objects in a situation where they could possibly become emotionally invested in, despite the fact there is little reason why they should be. And the objects are real ornaments; they are very decorative, and people could easily think they are tasteless or embarrassing as art, although they are quite beautiful in a strange way because they are so well made. Embarrassment is all about people's expectations. There are expectations around how a work is made, how it is positioned, what ideas it seems to be giving off. I am quite happy for people to see the work and think it is reductive or nostalgic or traditional, but I'll include something in the work that introduces a doubt about whether it is or not. The doubt is just another gap. It's the uncertainty that I want to inhabit the work.

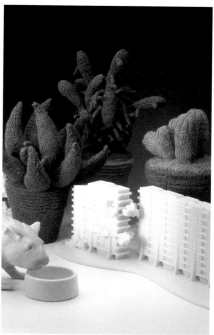

Home Ornaments
2002-05 (detail)

Simon Morrissey is an independent curator and writer on contemporary art.

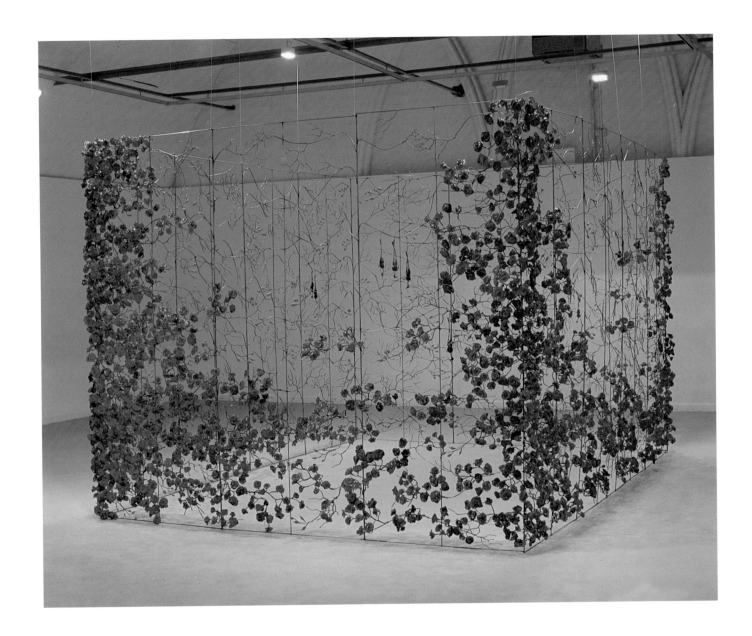

Once more
without feeling

ISABEL NOLAN

A PAIR OF HERONS NEST NEAR TO WHERE I LIVE: FROM TIME TO TIME, WHILST OUT WALKING THE beach, I see them, two spectres hunching in the shallows, or a lone sentinel upon a rock. Foolishly I persist in trying to get close, hoping to scrutinise them at leisure. Only once have I got near enough to see their scraggy feathers clearly, to see them briefly as real birds; seconds later their huge wings unfolded and they removed themselves to a safe distance, once more becoming mythic, enigmatic, but dully sleek.

On approaching a Daphne Wright work I think many viewers have experienced a certain deflation – the disappointment of a seduction proffered and then denied, proximity to the work making a lie of the easy charms that were promised from afar. It takes only a moment to realise that this disillusionment propels the work into a far more interesting corner of the mind than if they had a simple, obliging beauty. It is a fascinating quality, consistently observable in Wright's practice for many years now, a determined resistance to permitting effortless satisfaction. One can discern recurring tactics of dislocation, of peculiar and difficult juxtaposition; these strategies are apparent both in her approach to subjects and the way that Wright makes and presents the work. When we expect fragility, we find obduracy;

They've taken to their beds
1997, tin foil, metal and paint,
240 x 450 x 360 cm

instead of exquisiteness, we discover shabby charm; what looks initially like generosity and abundance belies a paucity of spirit or material poverty: Wright, it seems, will not allow the work be lovely, to be straightforward, to be sweet or blithely humorous. Instead of delightful myth we get weird allegories of sorts, or an often acerbic realism tempered by a mordant and revealing wit.

Wright's attention seems attuned to the darker side of life – estrangement, subjugation, confinement, isolation and, naturally, death. Nevertheless, this litany of sorrows expresses nothing of the intermittent warmth in her oblique approach, or the humour, the absurd touches, dark and light, that undercut the gloom of many of her works – work such as the disquieting and beautiful *They've taken to their beds* (1997). (The phrase describes the decision of an elderly person to patiently await his or her death, sometimes for many years, in bed.) It is an elaborately modelled sculpture: a vine 'grows' through a four-sided wire cage, the branches in places yield an abundance of roses and elsewhere are hung with the corpses of many tiny 'dead' herons. All (vine, roses and birds) are made in tinfoil and coated in blood-red lacquer. While *They've taken to their beds* deals in a prolonged moribundity, *Nonsense and Death* (1998) articulates a suspension of decay. It consists of four rows of skeletal trees 'sprouting' out of concrete bases. A heavy growth of funereal black fruits and flowers grow from some; other trees are nearly bare, a pair of fleshy pink herons perching separately amongst the branches. Playing over the installation is the voice of a woman reciting, without pause, Edward Lear's nonsense rhymes about assorted old men and their ridiculous deaths. The herons, though mates for life and a symbol of lovers, look like ghosts – silent, watchful occupants of the black, ghastly trees.

I have never really subscribed to the view that in moments of pain or rapture it is useful to be reminded that many before have shared your emotions. To be comforted or chided thus merely belittles and, perhaps, even degrades the experience; you are made mindful not only of your excess of feeling, but also of the quotidian banality of most events. Artists of a rare calibre have mined the core of love or loss and found something revelatory – be it wonderful or terrible. Unfortunately, many more merely add insult to our injuries by demonstrating in mundane terms the ubiquity of all experience. It seems that for much of her career Daphne Wright has very consciously taken a different strategy, approaching her subjects at a tangent. The work never presents finite statements. Rather, Wright displays a set of pared motifs that are communicative but not transparent; her installations establish a set of references that carefully situate the viewer without signposting a goal or announcing an opinion. It could be held that she picks and worries at, rather than tackles, experiences or feelings, dissecting or simply signalling a subject, and determining that it stand, somewhat pulled apart or exposed.

Her works demonstrate an elasticity of thought, an ability to bring about peculiar juxtapositions that go beyond a simple surrealism or a glib postmodern rapprochement of high and low. She also displays a restraint and a trust in the ability of things, of images and sounds, to speak, as it were, for themselves. This intuitive and consciously flexible approach is also apparent in the variety of materials with which she has worked. She moves – easily it would seem – from one medium to the next, attentive always to its potential and limitations. Wright has worked with casting and modelling, with plaster and tinfoil, with film, photography (both found and her own), and frequently with sound. This is not a marker of a self-conscious flippancy or fickleness. Her freehandedness is measured and matched by a doggedness in the crafting of work – the tedious process of making something once and then making it another fifty or five-hundred times. Eventually, when a medium no longer feels fresh or can no longer 'speak' of a subject, she moves to something else, learns a new language, and seems to set about discovering its possibilities.

Repetition is a strategy Wright has frequently used. In *Domestic Shrubbery* (1994), multiple crude plaster renderings of a single wallpaper motif are suspended a foot from the wall. The repeated floral pattern forms a floating cage inside the room, and within the plaster design many tiny anatomic hearts dangle. They are mean, shrunken organs, disembodied, preserved but lifeless. The cold, white plaster is rough and unpainted. What seems in reproduction to be a fragile, delicate construction was, in actuality, messy, the mechanics of its production and

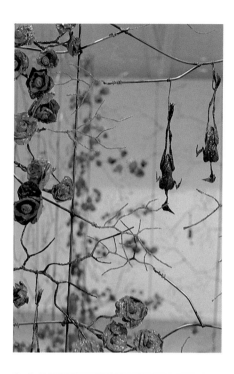

They've taken to their beds
1997 (detail)

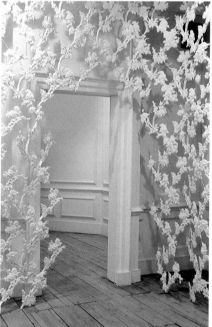

Domestic Shrubbery
1994 (detail)

installation laid bare. This is no nostalgic and precious evocation of bygone times. In the room, a woman's faltering voice calls cuckoo, her pitch rises and falls; both playful and taunting, it elicits thoughts of absent children and of interlopers. Maybe it is their atrophied hearts strung up around the trellis walls? Or maybe the hearts belong to those who decorated this room, those who regulate how and to whom love can be given. The wallpaper recalls aspirations to grandness of particular periods, but the desire to make a beautiful home is in every generation, a house in which to keep hearts safe, or ensnared. These particular walls seem to require you to attend to your surroundings, that you be uncomfortable and fearful, that simply by relaxing, by moving freely, you may shatter something valued or, conceivably, break with values. If this room was built with love it seems to be an emotion that ossifies and binds, that turns something 'natural' into something deathly and lifeless. It is easy to picture Dickens' Miss Havisham training Estella in the ways of neither giving nor responding to love in such a home. Wright drains the wallpaper of richness, of colour and comfort. The work evokes a carefully, a tough, a beautiful, if crudely wrought, cold but fragile cage, and in so doing has made a visceral but bloodless 'living' room.

Much of Wright's practice has been quite theatrical. Sculptural forms, sound and photography are thoughtfully staged in an arena ready to receive the performer/viewer. She presents a set of motifs visual and aural, each deprived of its very particular individuality, pulled far from the conviviality and padding of a precise context. Every element is rigorously mediated, distanced, made into a cold cipher or a lukewarm, but hesitant, enactment of something that once was real. Often each element feels drained, deprived of any core or vital identity, but as a set piece of allusions they rub and push uncomfortably and evocatively against each other.

In the exhibition *Where do broken hearts go?* (2000), occupying the main bunker-like area of the Douglas Hyde Gallery, were seven large silver sculptural forms. These uncomplicated shapes, visible in the first instance from the upper level of the gallery, were utterly legible as cacti, but they bore only a schematic resemblance to their fleshy, green, living counterparts. They

looked like slick props from a B-movie vision of a shiny, distant space age. From this vantage point you could see that the cacti were hollow. Only where an arm had been 'pruned' was the end sealed; otherwise the tops of the main trunks and branches of each were left open. Nothing more than the darkness of the interior was visible. This understanding of them as hollow seemed crucial in determining them more as props than as discrete sculptures that could ask of us to believe or involve ourselves in their comic strangeness or to imagine a narrative to account for their existence. Their incompleteness declares, as in Wright's other work, the mechanics of their facture, and hence binds them absolutely to their relentless artificiality, to the plane of what is here and what is now. She effectively circumvents an engagement with them as autonomous or metaphysical phenomena, denying these plants any possible plausible existence outside of their representation.

As a reference point, these cacti lead us in several directions: to nature – a life form capable of both flourishing and nurturing in an extreme climate; to the wild west of films (or cartoons), where cacti denote a harsh existence where life is brutal and hard won (and provide easy laughs). And in this instance, devoid of life, though not of humour, they also invoke an idea of a 'future', when everything will be efficient, man-made and clean.

Playing in the gallery is an audio piece, a monotonous recitation by an older woman of histrionic tales of broken hearts and senseless death (in this instance the brutal murder of a young girl and a tall handsome stranger), read without feeling. The content quite quickly reveals them as lyrics typical of country and western songs. It is not a great leap to connect this stripped unemotional delivery of 'heart-rending' tales of woe with the setting of lifeless cacti. These are features of a terrain with particular and peculiar connotations of independence and self-reliance. Feelings were a luxury or encumbrance that emasculated, and so steadfast but uncommunicative hearts broke and the violent murder of others, be they a threat or a burden, was normal. As comparable with *Domestic Shrubbery* or *Lot's Wife I* and *II*, the features of this landscape have been drained of colour, leached of voluble expressiveness, and all that

Where do broken hearts go?
2000

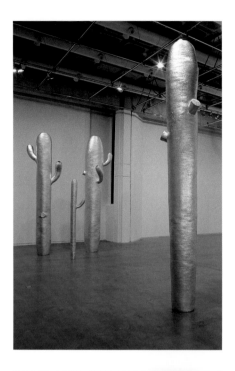

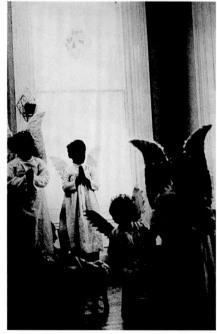

22

is left to the viewer is the empty shells of these heady signifiers. What does it mean to represent such melodramatic 'territory' as virtually lifeless and without evident feeling?

The final element in the installation was a suite of nine prints. They pictured poorly furnished rooms, children engaged in various activities, and the nuns who were supervising them and residing and dying within those walls. The ordinary, if generally unseen (though patently not an 'exotic, hidden' everyday-ness), dull subjects and the ascetic and impoverished scenes represented are not especially aggrandised, but they are attended to, which is an investment of interest or even care into the prosaic lives of these children and nuns from the 1970s. The sisters' residences as arenas for human activity seem clearly delineated; we understand them as places of constraint and duty that enabled a certain kind of spiritual freedom. Though several of the scenes depict what should be moments of happiness – kids' plays or a sunny day in a garden – they look somehow cheerless, and are pervaded by a black and white gloom. Every time I look at them I feel convinced the anonymous subjects are all long dead. The photograph of children dressed as angels with clasped hands, or of a nun playing the piano, has the same remote quality as one of an old woman in her coffin. In the same, undifferentiating muted light, we are presented with a record of important and insignificant moments from a secluded, unmemorable community. The selection Wright presents (from an original eight-hundred-plus) would suggest that the nun photographer was unable to reach anyone in these pictures, incapable of breaching the uncomfortable and formal distance that separates her and all the subjects. Like any uniform, the habit conceals a certain amount of personality, and wearers bear a responsibility to behave decorously; there is no physical intimacy between the sisters themselves or with the children.

Presumably, in order to pursue a meaningful earthly existence and a religious joy in the service of God and all his children, the nuns led lives of behavioural restriction and material deprivation. Perhaps an analogy is being drawn between two very different ways of life, both of which limit the possibility of joy in expressive, intimate relationships. The get-up of the cowboy (the life of the macho man) determines that he be physically courageous, independent and powerful. These men chose a life that meant they could ride into the sunset and risk a premature death in the pursuit of freedom, opportunity and wealth, but forbade them expressing 'feeling', forbade that is, the display of weakness.

Up close, the cacti are revealed to be fashioned from hundreds of narrow strips of folded tinfoil, painstakingly overlapped. Their silvery surfaces are not precious or alluring; in fact, they look a little beaten and plain. Tinfoil, in this instance, in such proximity is distinctly unglamorous. The cacti are not shiny nor futuristic; rather they are cold, almost cheap, sterile and oddly vulnerable – easily, one senses, dented or torn. Unlike their real counterparts they are neither robust nor flourishing and are utterly detached from their surroundings, resting on a blank concrete floor surrounded by high white walls under a cold, bluish, even light. Equally, though the photographs are beautifully printed with rich deep tones, the attention to what were clearly amateur 'found' photos seems only a variation on Wright's practice of utilising everyday material. In this instance she is adding a certain gloss to banal images. The end result presents a similar tension to that found in much of her sculptural work – in the former, the luscious reprinting of amateur photographs, and in the latter, the rendering of attractive or delicate forms in low or unsophisticated materials.

Quickly enough, the unchanging repetition of the hackneyed and melodramatic lyrics ('little Blossom seeking care but finding death at the hands of her violent drunk Daddy, the heart that has had its share, and the bullet that spills blood') by a woman whose ordinary, untrained voice could be that of one of the pictured elderly nuns, becomes annoying. The artificial, faintly stupid cacti stand firm and uncommunicative, and on the walls are photographs of ghosts, banal scenes from some very distant lives. There is no sadness in the recital of the lyrics – only an irritating and sentimental imitation of pain. There is only coldness in the giant, deadpan cacti, and a sense of an isolating self-discipline in the nunnery. As viewers we are (most of us) made endure a series of exclusions. We are in an alien, fake landscape, adrift from anything real or natural – a terrain

evocative of a misanthropic, brutish past or an artificial, cheap future. Positioned outside of sentiment, we are denied even a pleasure in popular song or the opportunity of empathising with the remote nuns or children. It seems to me that there is little tenderness in Wright's installation; rather there is coldness and even pitilessness. However, these instances of separateness, this reiteration of isolation and human disconnection on many levels, describes ultimately a fundamental loneliness. The dearth of either warmth or pain in the installation turns on the viewer; it both revolves around your presence and necessitates that you, if you engage, connect all the disparate strands and act as an interpreting subject. Like *Domestic Shrubbery*, *Where do broken hearts go?* situates you in a moment of displacement. It is almost an emotional abyss, arousing pathos, perhaps, or at least provoking a desire to occupy this void with meaningfulness. Wright has described her installations as a kind of 'sulking', her use of sound as an 'itch'. These strategies perhaps goad one into finding the feelings that belong in these spaces, be they the 'cage' of *They've taken to their beds*, the orchards of *Lot's Wife* or *Nonsense and Death*, the room of *Domestic Shrubbery*, or the tripartite installation of *Where do broken hearts go?* The works constitute a kind of passive aggression, forcing you to wonder and to discover what is wrong with or absent from 'this picture'. By draining a subject of vivacity and refraining from any heightened or expressive representation, Wright has made work that clamours to be satiated, vivified, to be made meaningful with feeling.

It is possible to mark general shifts in Wright's practice from the literal, sculptural enactment of disjunction in early works such as *The Return of the Prodigal Son* (1991), to more ambiguous poetic elaborations of existing in suspension – *Domestic Shrubbery*, *Nonsense and Death*, *Indeed, Indeed* (1998), and *They've taken to their beds*. *These Talking Walls* (2001) seems, like *Where do broken hearts go?*, to be an even more ambitious and oblique staging of human solitariness, a more fragmentary, tougher installation. Interestingly, *Sires* would appear to mark another distinct shift. As a body of work it has a clear and consistent focus, its origins in the world of cattle breeding. Seen in Frith Street Gallery in 2003-04, *Sires* consisted of a group of clearly individuated but related works – a series of photographic

continued on page 73

The Return of the Prodigal Son
1991, plaster, wood and continuous loop tape,
914 x 305 x 91 cm

sound: conversation between two women from different generations speaking about accent

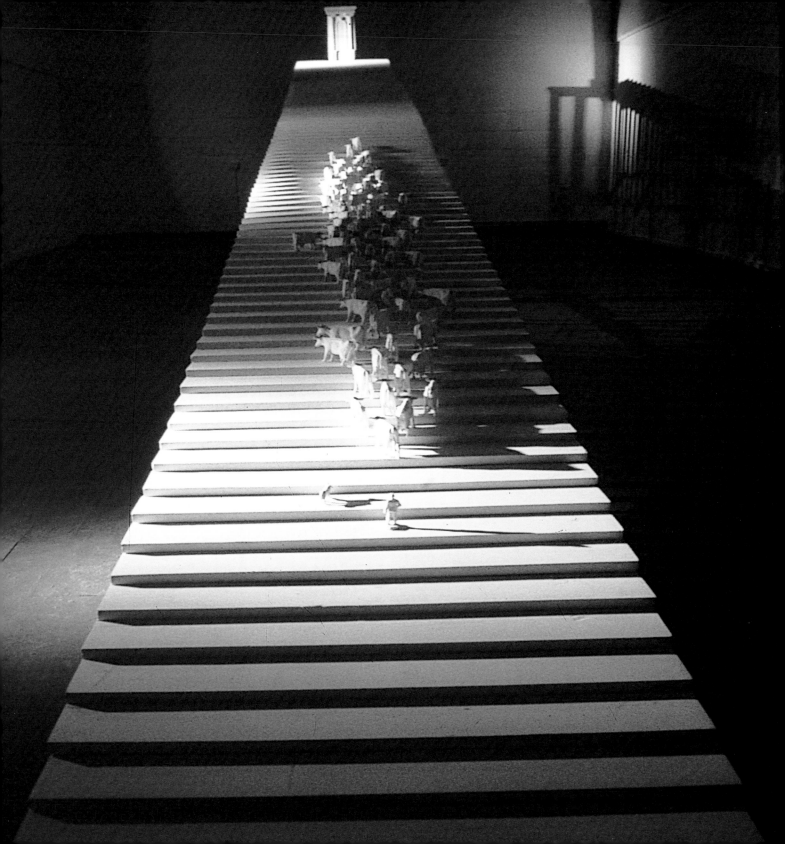

The Return of the Prodigal Son

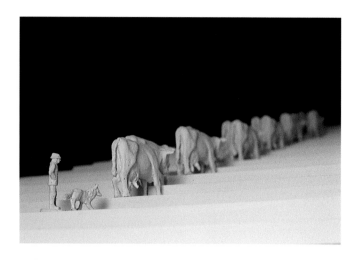

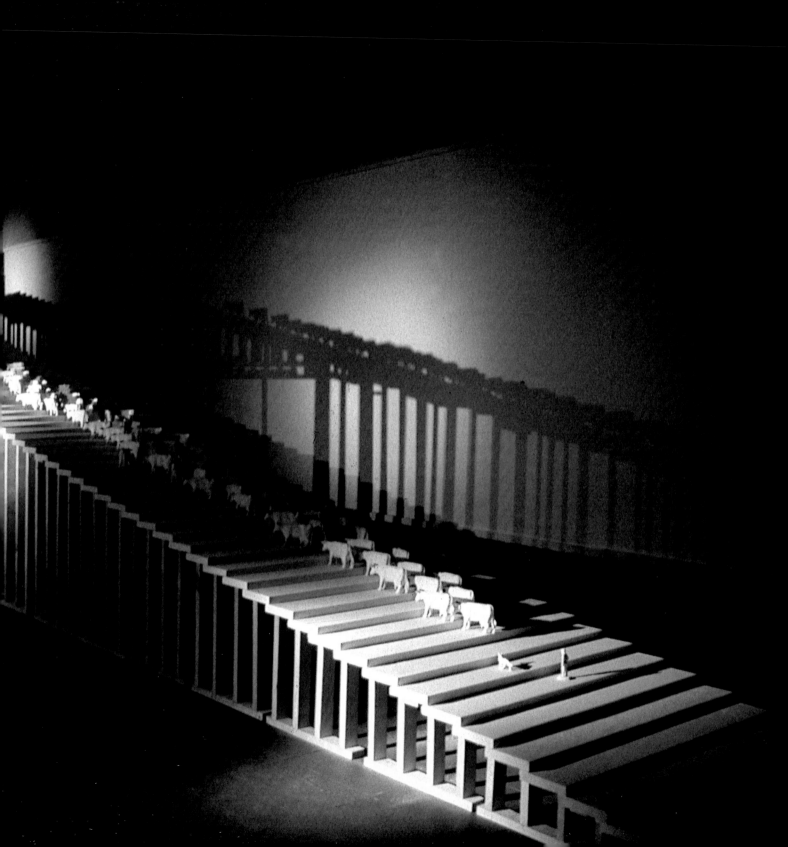

Looking for the Home of the Sickness
1992, plaster, metal and continuous loop tape,
457 x 366 x 600 cm

sound: person waffle-whistling as a
workman whistles

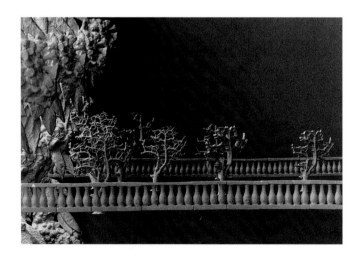 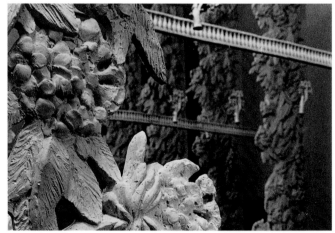

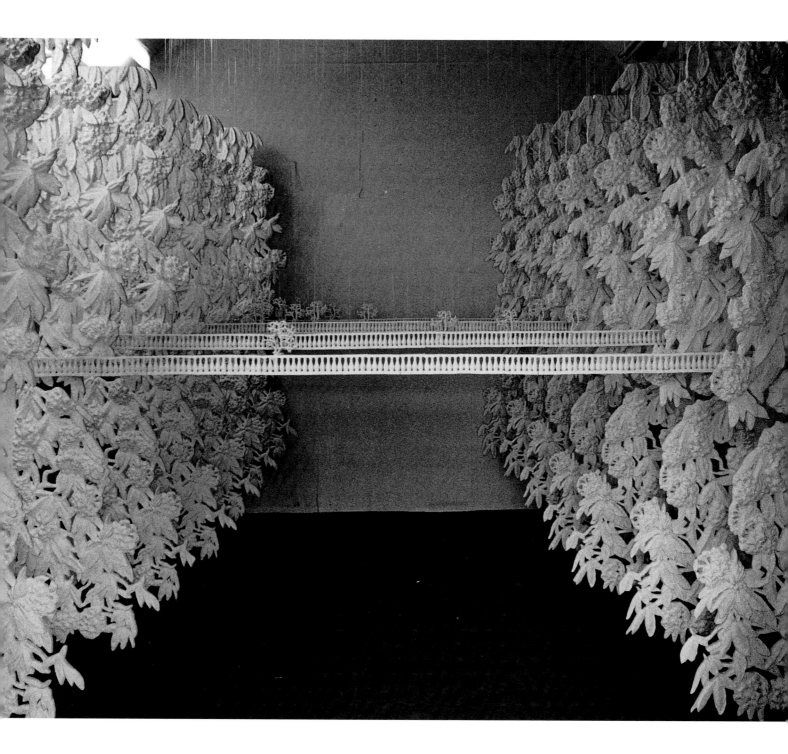

The Call In

1994, plaster and continuous loop tape, 411 x 320 cm

sound: person calling, driving and making coaxing
sounds to bring animals in from the field

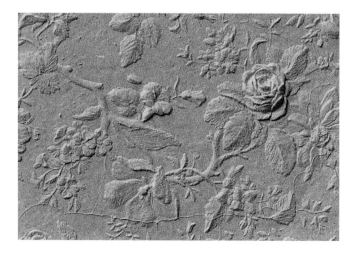

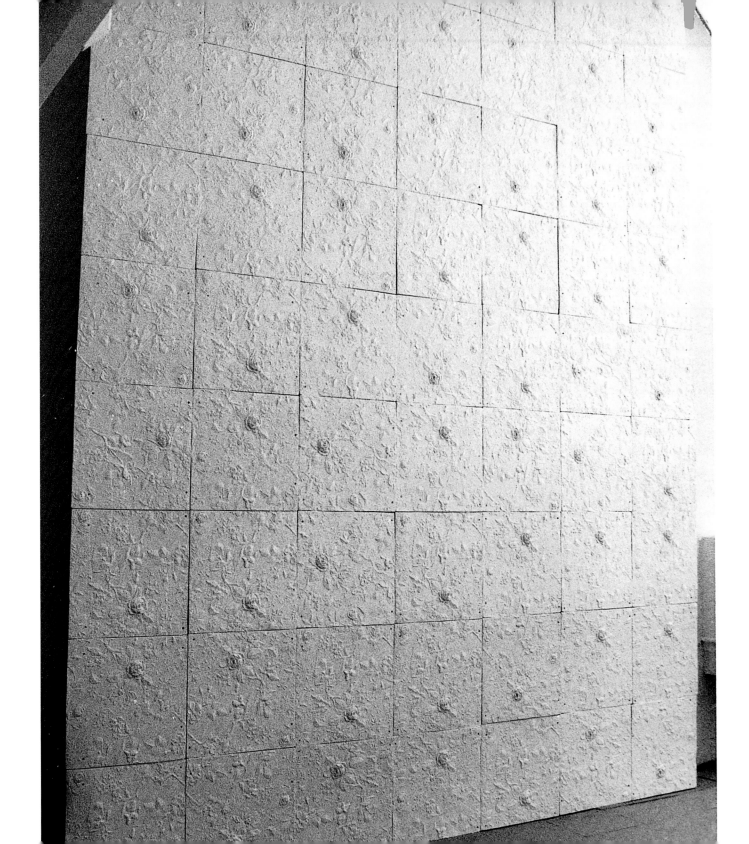

The Pretender
1994, plaster, 853 x 122 x 76 cm

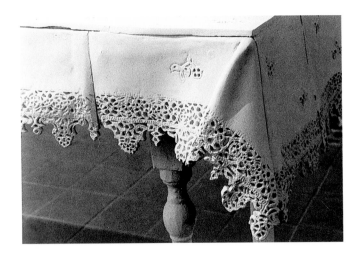

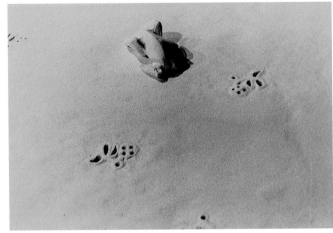

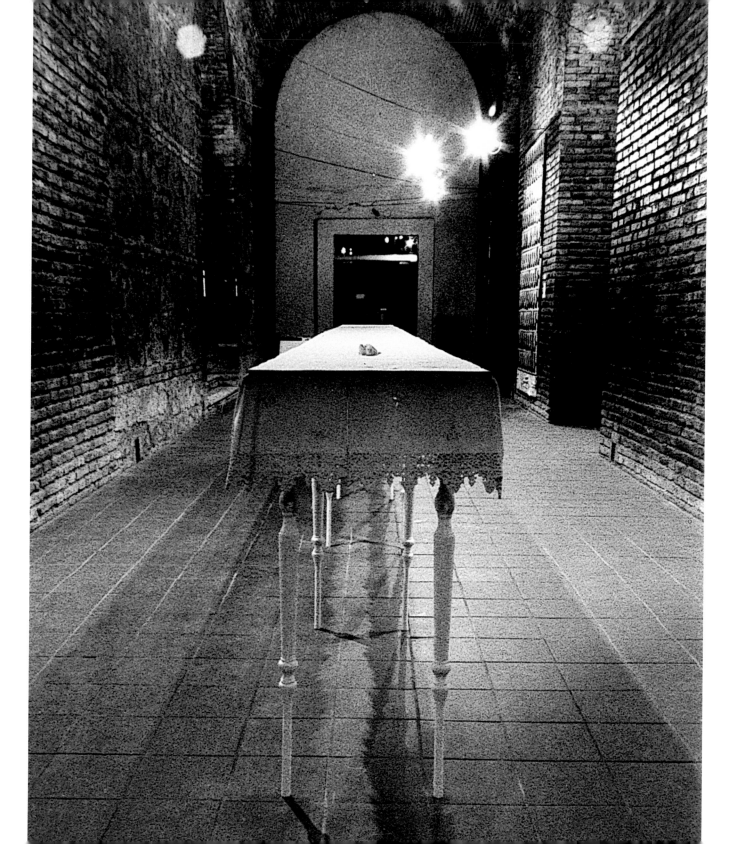

Domestic Shrubbery
1994, plaster and continuous loop tape,
488 x 457 x 366 cm

sound: middle-aged female voice imitating a cuckoo,
alternating between an intimate term of endearrment
and that of a bird in the landscape

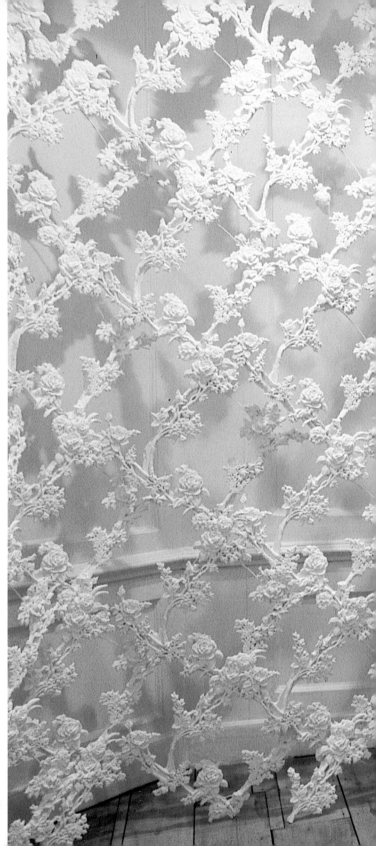

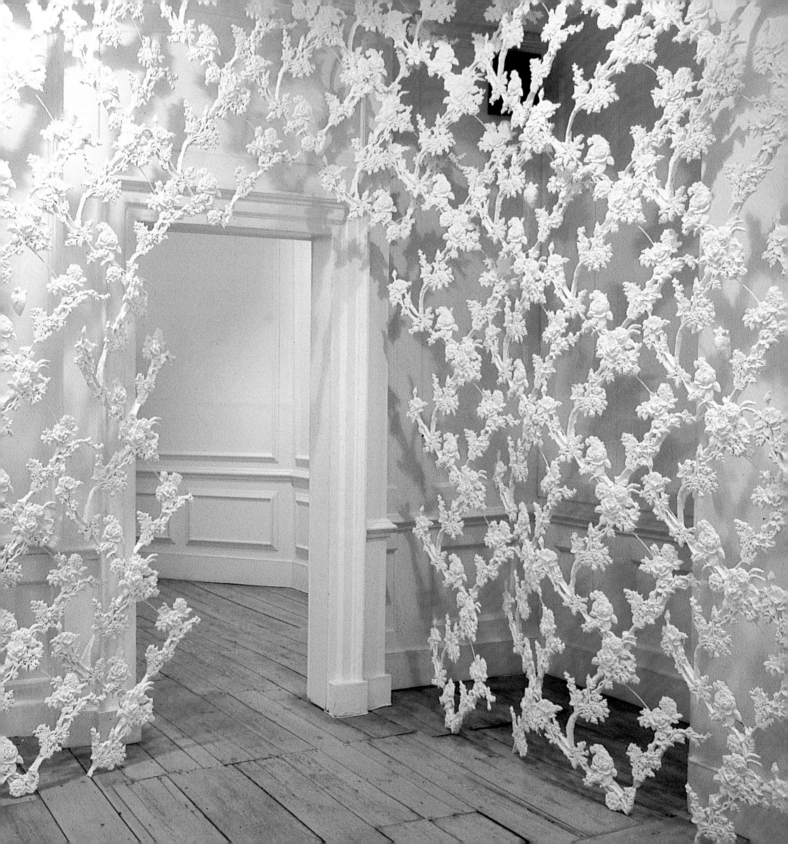

Still LIfe: The Greenhouse
1995, plaster, 305 x 152 x 198 cm
(installation at the Bowes Museum for the
Henry Moore Institute)

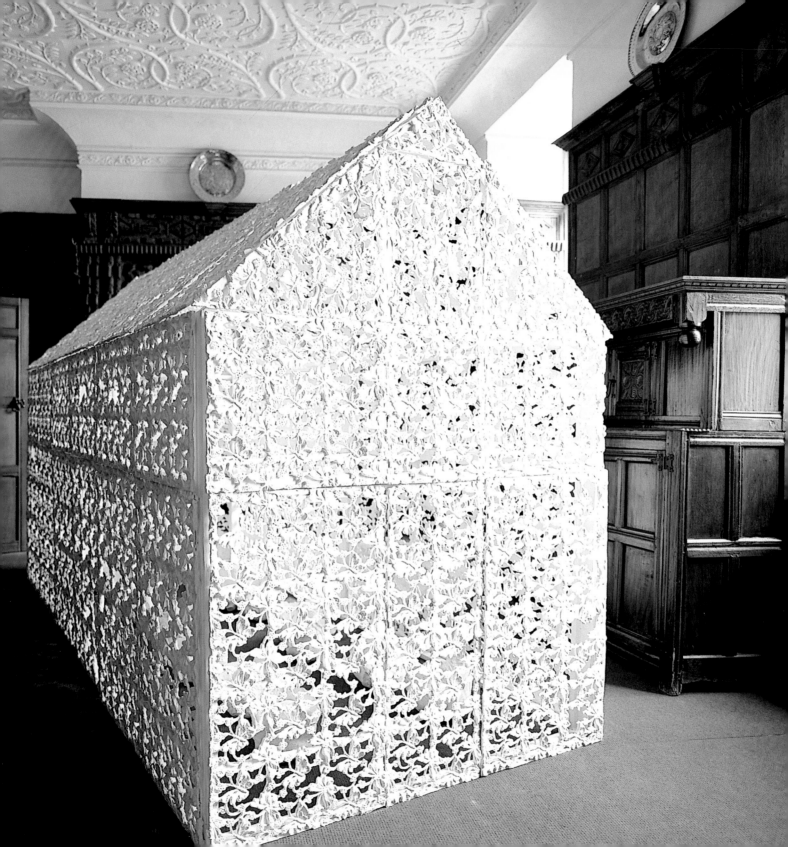

Lot's Wife I

1995, trees, tin foil, wire, concrete, sellotape and continuous
loop tape, 305 x 762 cm, but variable

sound: old man's voice (low and rasping) repeating,
'You're an April Fool... April Fool... Ach!... You're an April Fool...'

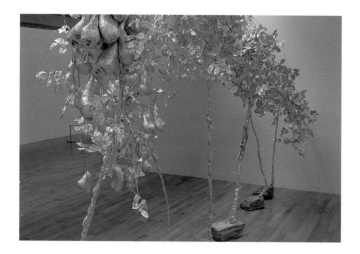

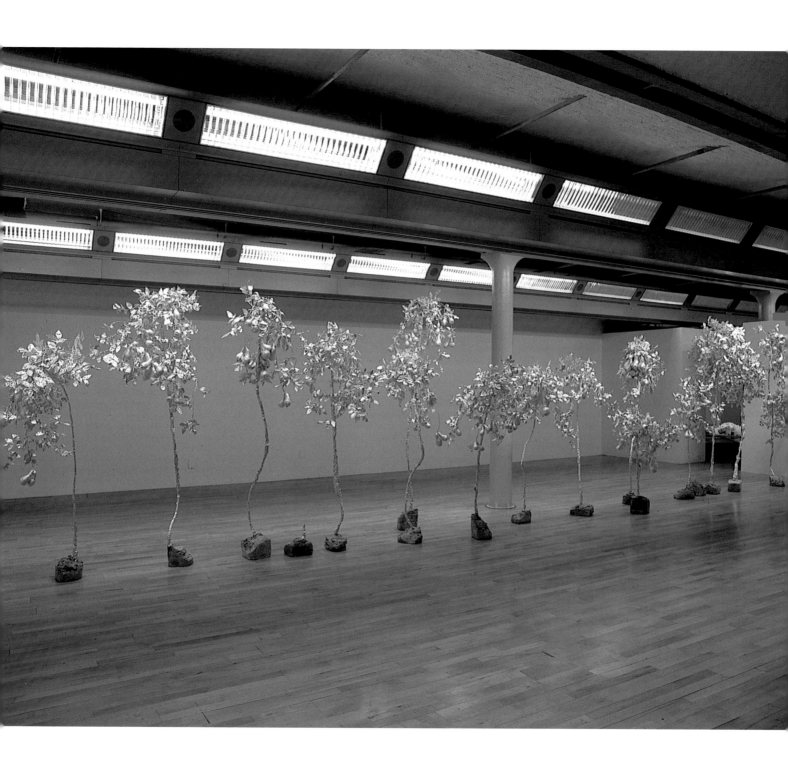

They've taken to their beds
1997, tin foil, metal and paint, 240 x 450 x 360 cm

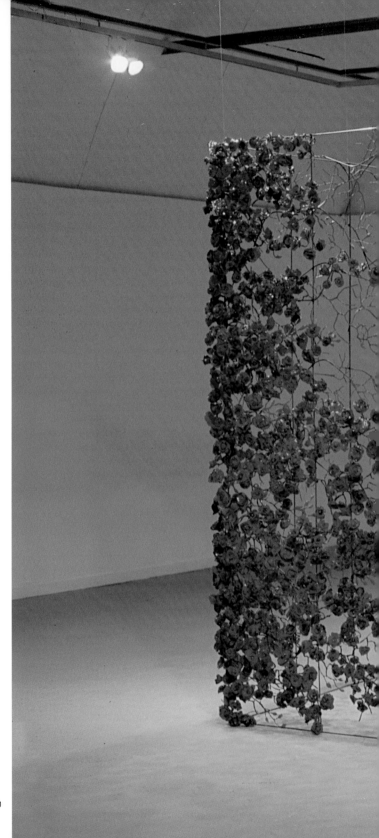

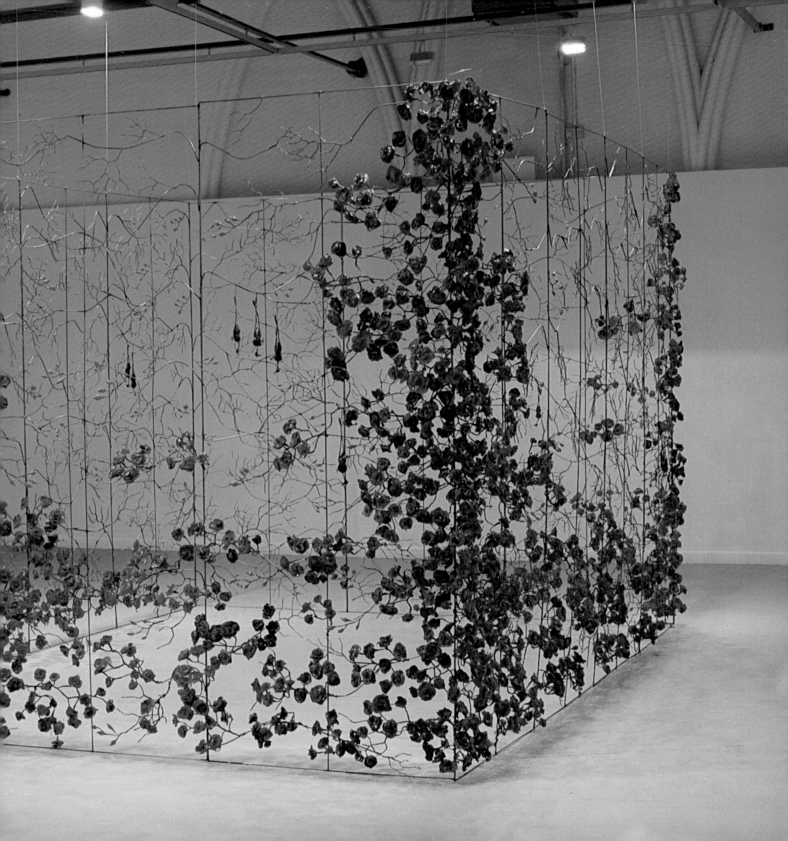

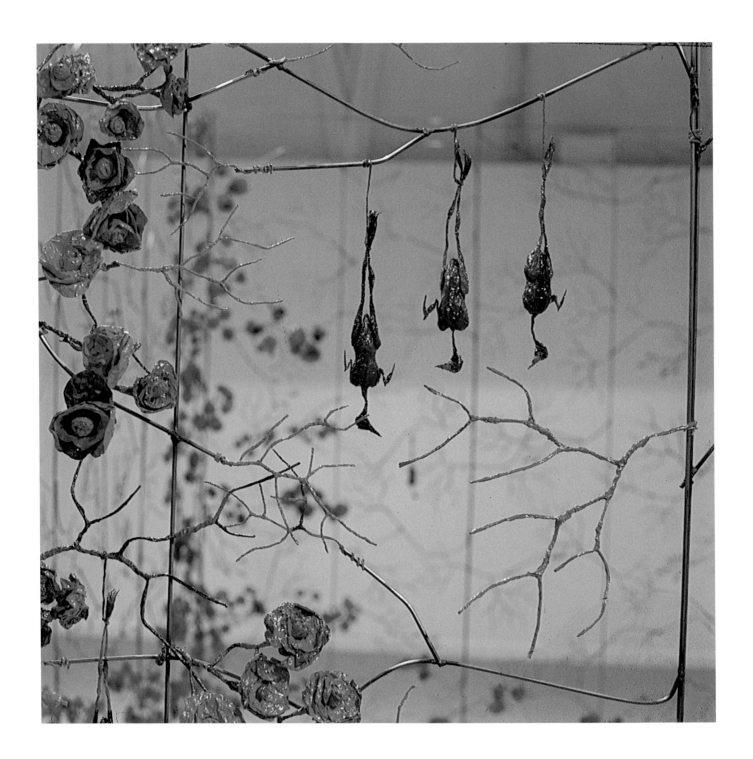

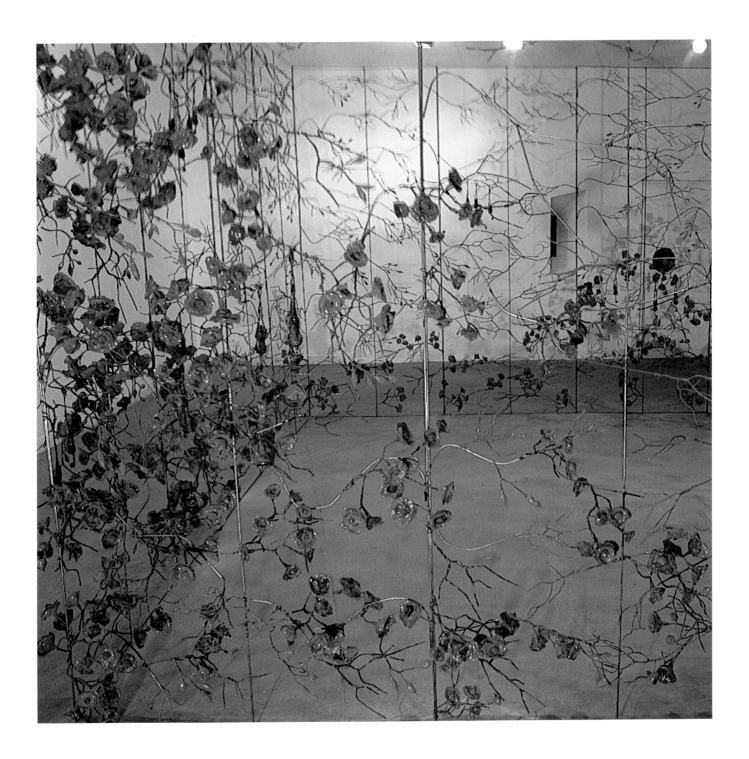

Indeed Indeed

1998, tin foil, glue and continuous loop tape,
dimensions variable but highest point 366cm

sound: theatrical male voice reciting
concatenation (or chain verse)

Deed'n deed'n double deed,
Deed indeed. I was dead indeed.
I was dead indeed
Like a penknife at my heart;

When my heart began to bleed.
Deed indeed. I was dead indeed.
Like a penknife at my heart
Deed indeed I was dead indeed.

Deed'n deed'n double deed,
Deed indeed. I was dead indeed.
When my back began to smart,
When my heart began to bleed.
Deed indeed. I was dead indeed.
Like a penknife at my heart.
I was dead indeed.

When the door began to crack,
Like a hickory at my back
Deed'n deed'n double deed.
Like a penknife at my heart
When my heart began to bleed.
Deed indeed.! was dead indeed.
When my back began to smart.

44

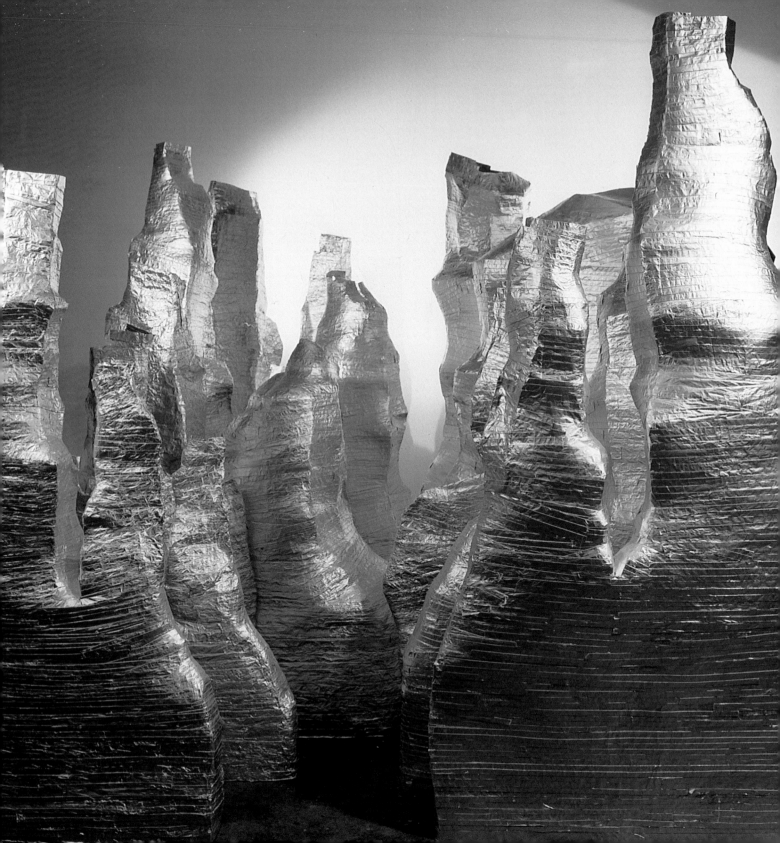

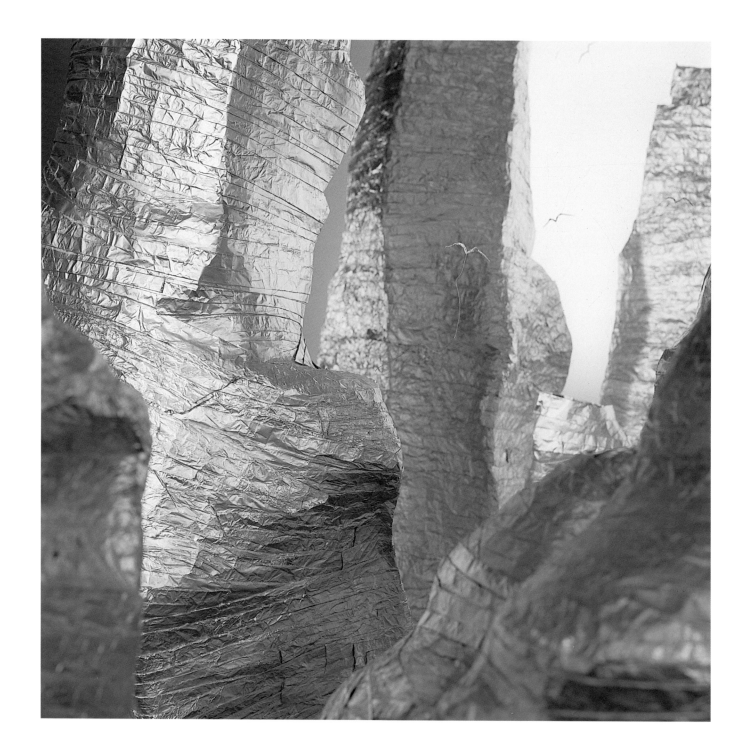

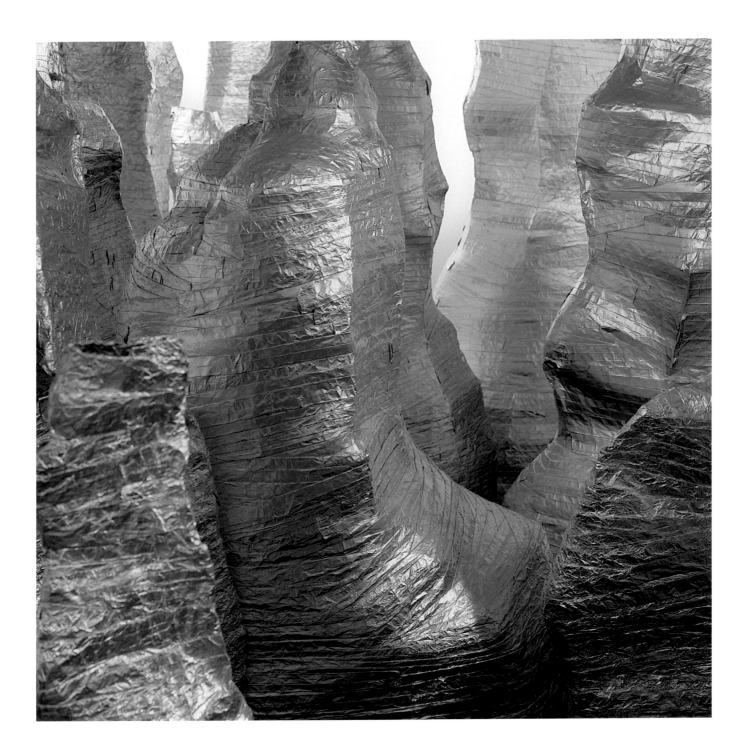

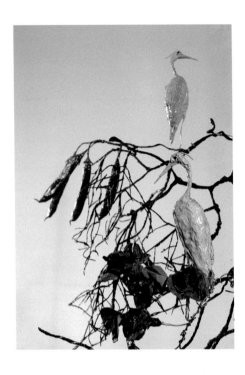

Nonsense and Death
1998, tin foil, wire, paint and continuous loop tape, 274 x 264 cm

sound: middle-aged woman's voice reciting
Edward Lear's limericks at pace

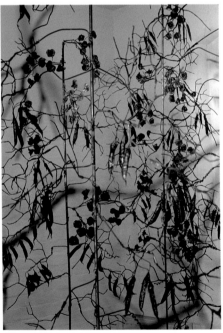

There was an Old Man on a hill, who seldom if ever, stood still,
He ran up and down, in his Grandmother's gown,
which adorned that Old Man on a hill.

There was an old man with a gong, who bumped at it all the day long,
But they called out 'Oh Law! You're a horrid old bore!'
So they smashed that Old Man with a gong

There was an Old Man in a tree, who was horribly bored by a bee;
When they said 'Does it buzz?' he replied 'Yes, it does',
It's a regular brute of a bee.

There was an old Man of Cape Horn, who wished he had never been born,
So he sat on a chair, till he died of despair,
That dolorous Man of Cape Horn

There was an Old Person of Cromer, who stood on one leg to read Homer,
When he found he grew stiff, he jumped over the cliff,
Which concluded that Person of Cromer.

There was an Old Man who said, 'How—shall I flee from this horrible Cow?
I will sit on this stile, and continue to smile, Which may soften the heart of that Cow.

[from Edward Lear, The Book of Nonsense (Simpkin Marshall Hamilton Kent & Co, London)]

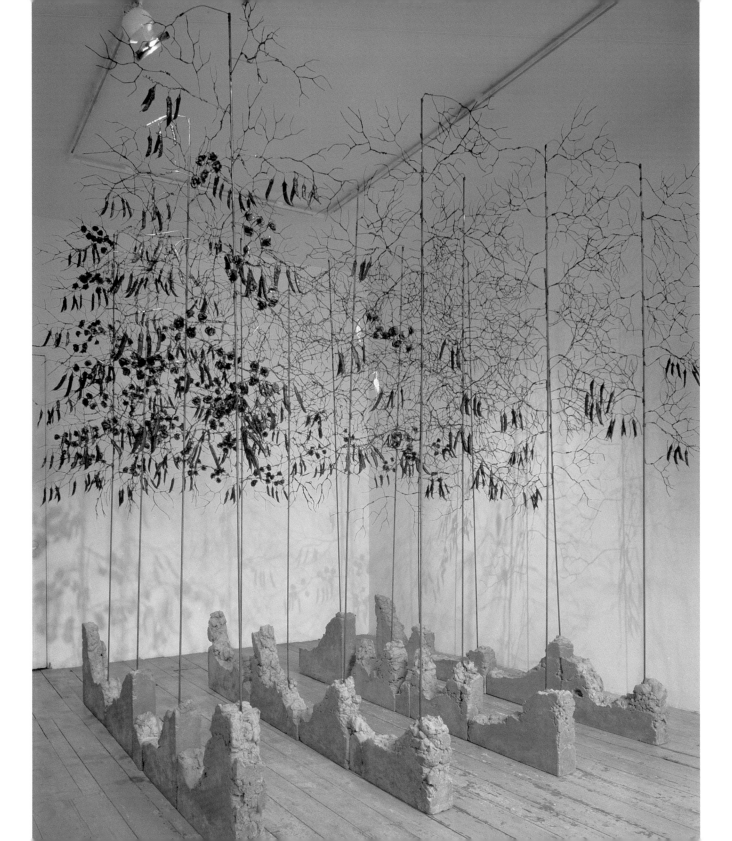

 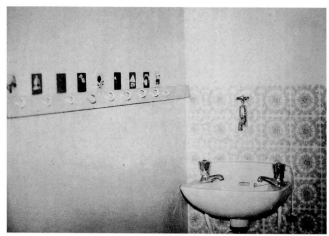

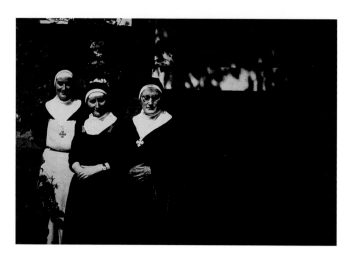 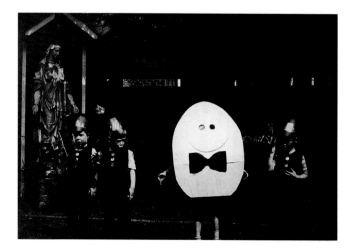

Where do broken hearts go?
2000, cacti, tin foil, glue, resin and continuous loop tape,
plus a series of 9 continuous-tone photopolymer intaglio plates,
highest cacti: 381 cm; prints: 29 x 39 cm (edition of 4)

(pages 52-53: installation at Douglas Hyde Gallery, Dublin)

The photos were edited from a series of slides purchased from a second-hand shop
in Manchester in 1995. DW would like to acknowledge the unknown photographer.

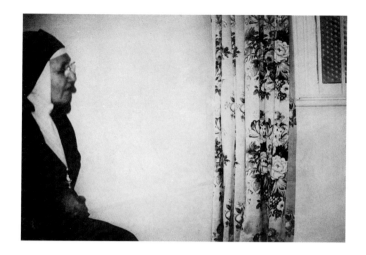

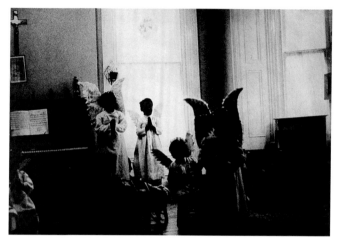

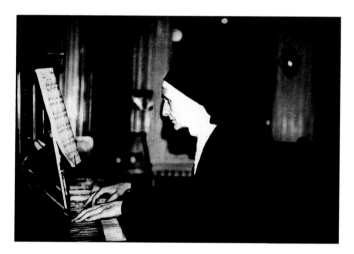

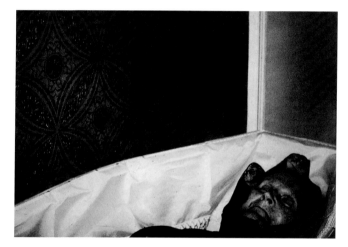

sound: woman's voice reciting C&W songs

He cursed as my bullet went deep in his chest
Slowly and lifeless he fell to the ground
The blood that I spilled was just like my own

[adapted from *Tall Handsome Stranger*, Marty Robbins © 1969 RCA]

Where does a broken heart go
when it dies of pain
Is there a heaven for broken hearts
– will it live again

[adapted from *Where Does a Broken Heart go?*, Mary Reeves © 1982 TRO-Essex Music Ltd]

For a moment his blue eyes gazed wildly
Down into her face sweet and fair
And as the demon possessed him
He pressed back the back of her chair

[from *Little Blossom*, Dolly Parton © 1985 Tring International plc]

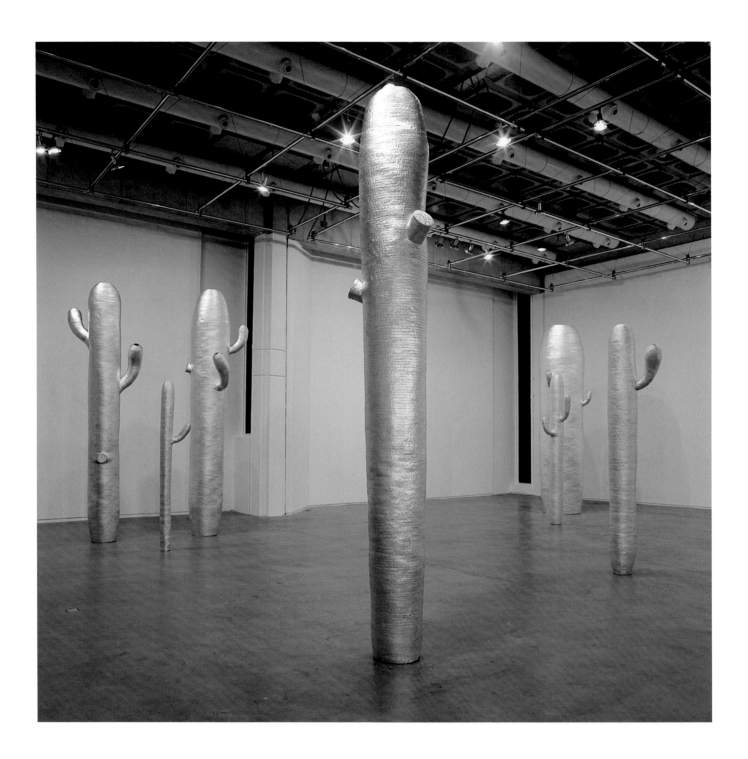

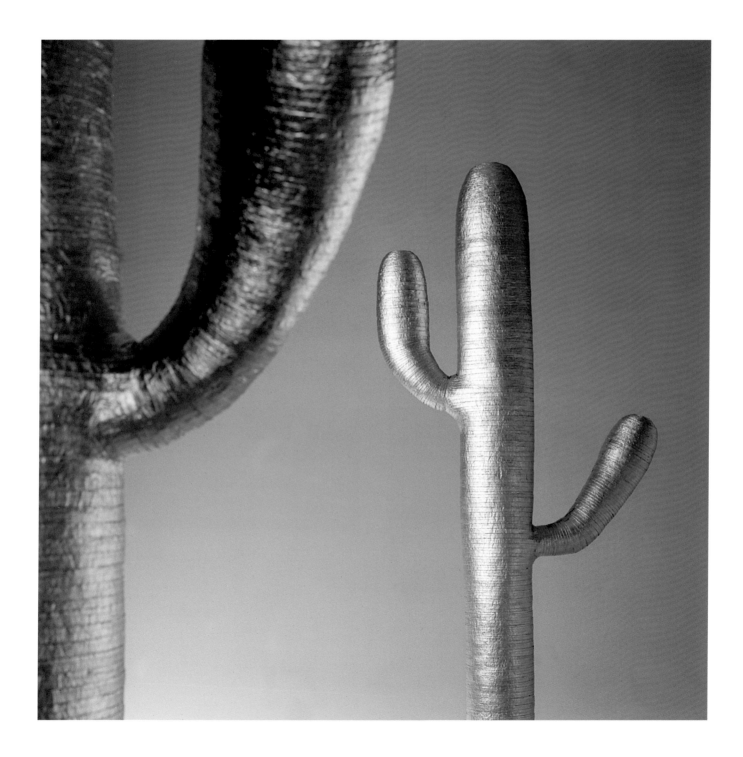

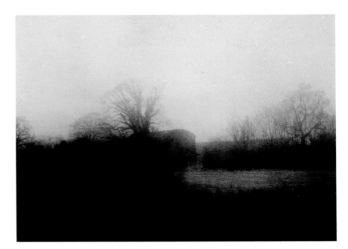

These Talking Walls

2001, 2 space capsules (tin foil and fibreglass) and continuous loop tape, and a series of 4 photopolymer intaglio plates, 137 x 122 cm (ed. 4)

sound: middle-aged woman's voice reciting country and western songs

every step we made you were there behind the talking walls [1]

and souls that cry for water, cool clear water, – don't listen to him [2]

[1] adapted from *Talking Walls*, © Sony ATV
[2] adapted from *cool clean water*, M Robbins, © EMI

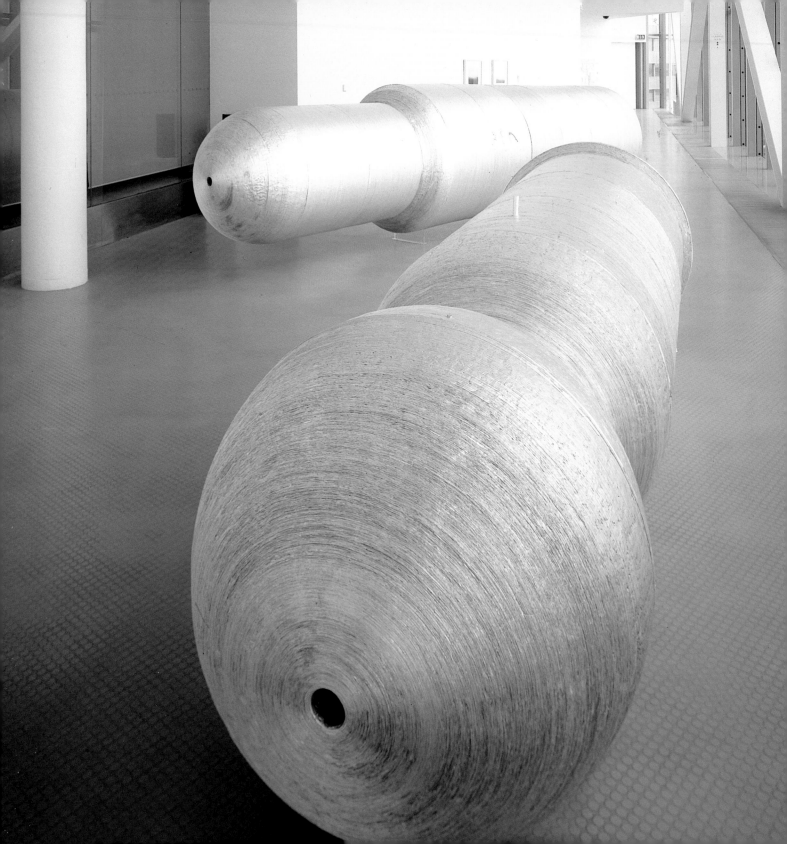

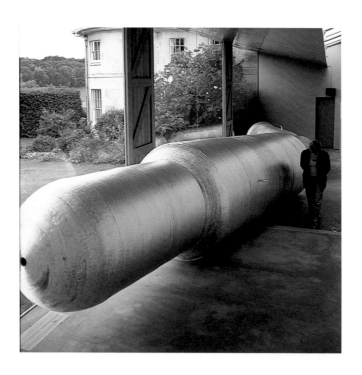

These Talking Walls
(installation at Roche Court, Salisbury)

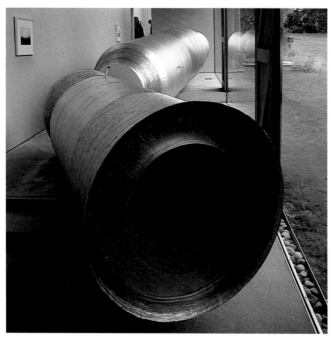

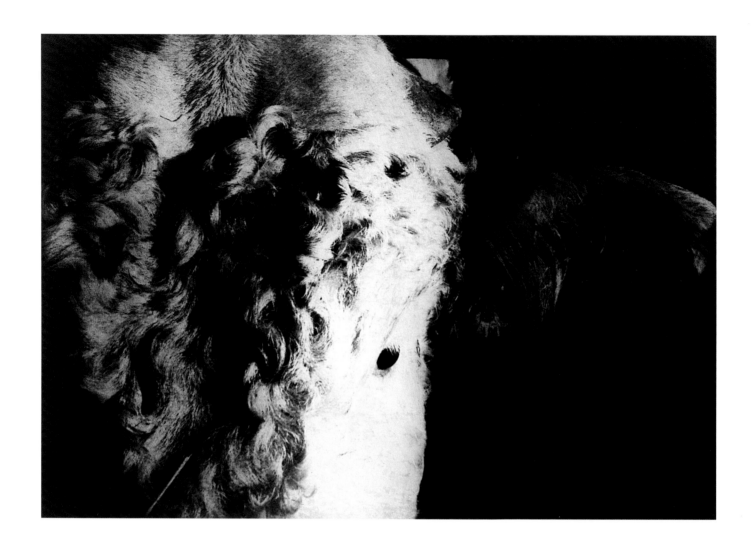

Bulls – Luke
2002, polymer intaglio print, 53 x 63 cm (ed. 5)

opposite
Bulls – Joe
2002, polymer intaglio print, 65 x 51 cm (ed. 5)

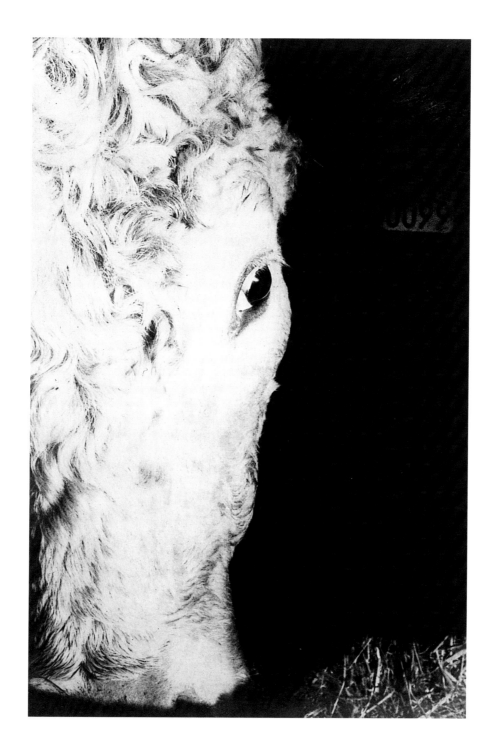

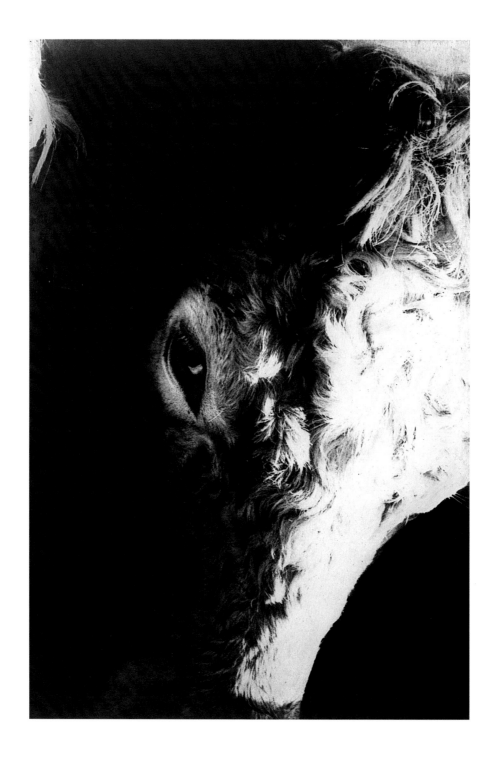

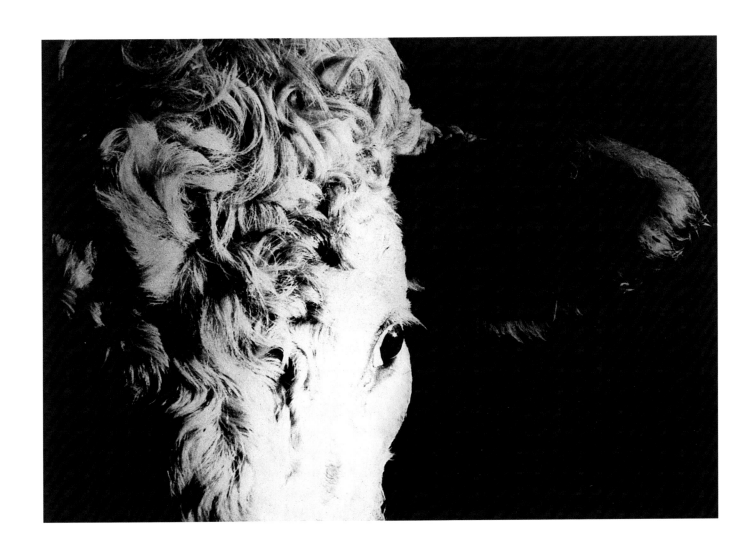

opposite
Bulls – Reuben
2002, polymer intaglio print, 65 x 51 cm (ed. 5)

Bulls – George
2002, polymer intaglio print, 53 x 63 cm (ed. 5)

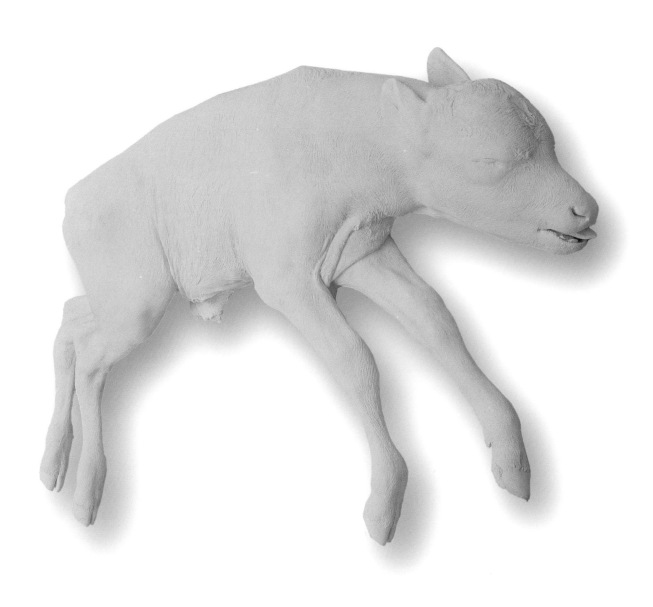

Stillborn
2003, chalk resin, 102 x 63 x 13 cm (edition of 2)

opposite
Death Mask, Horace, 14 June 2003
2003, painted plaster, 104 x 76 x 60 cm

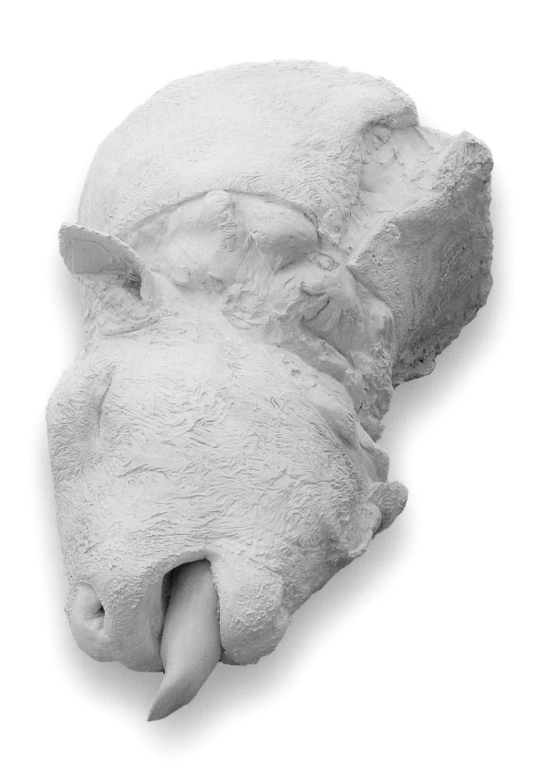

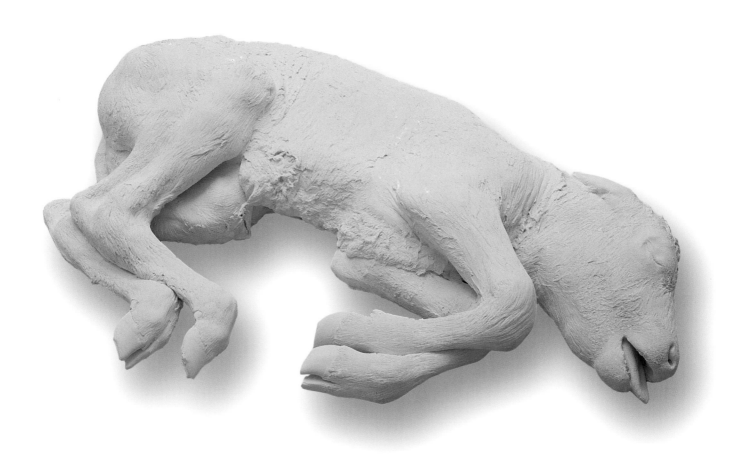

Stillborn, The Brute
2003, chalk resin, 102 x 63 x 13 cm (edition of 2)

Sires
2003, DVD loop, 3 mins
(film-maker: DW; camera: Mino de Francesca)

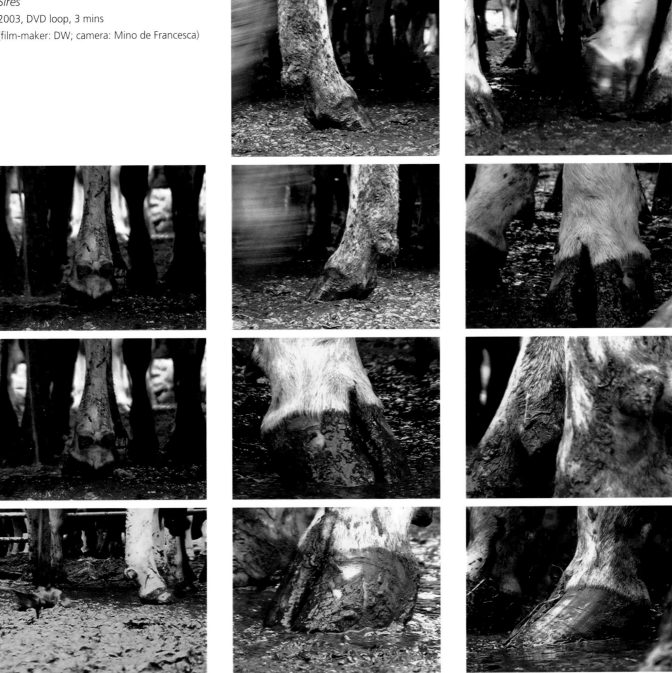

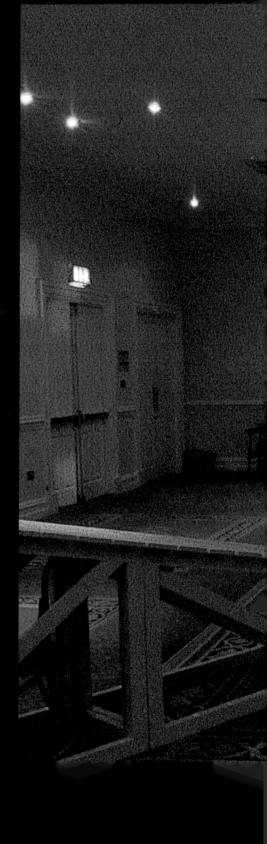

Croon
(see page 70)

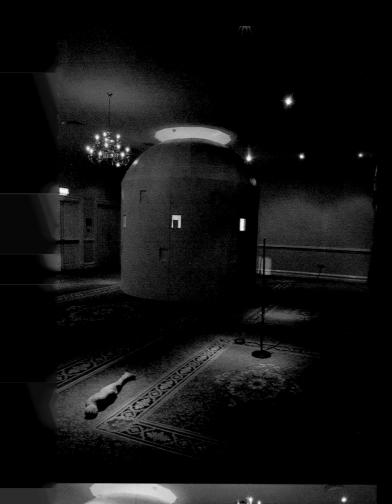

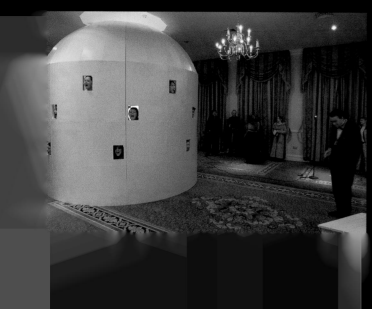

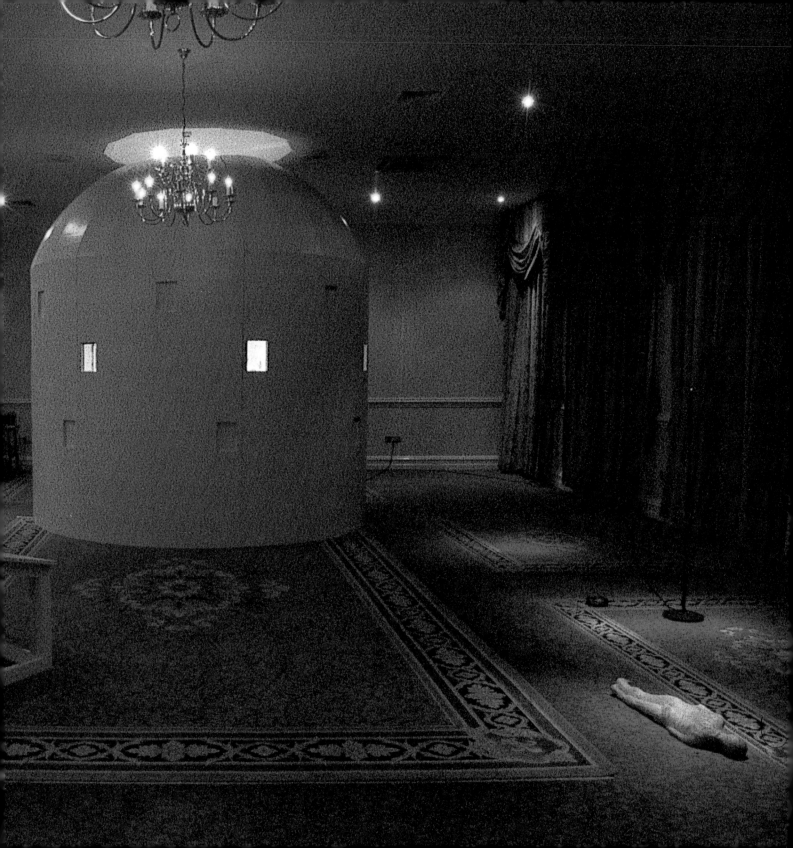

Croon
(see page 70)

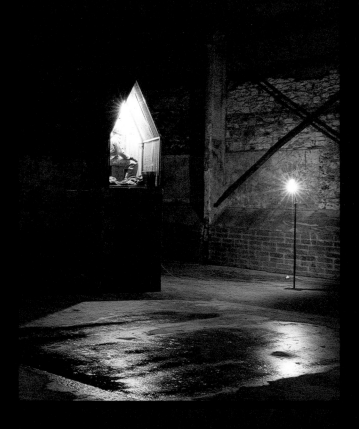

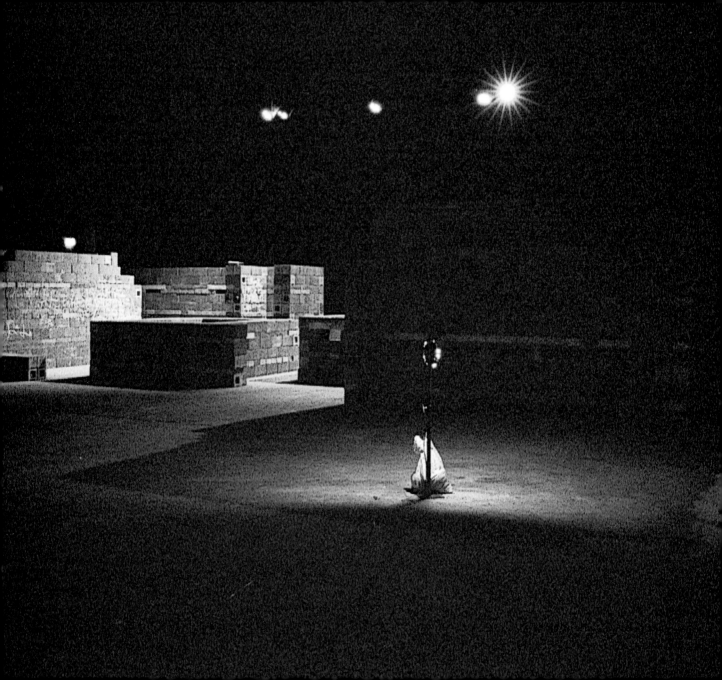

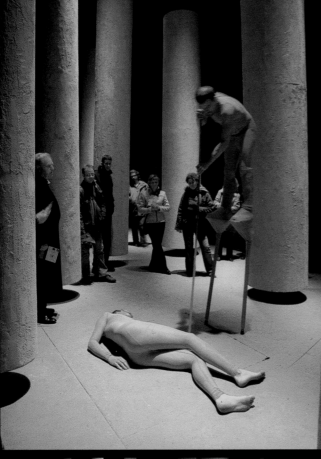

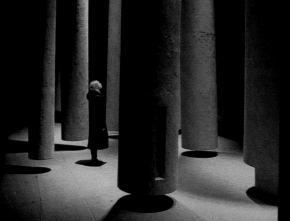

Croon
2004, collaboration between Daphne Wright
and Johnny Hanrahan
(presented by Meridian Theatre Company, Cork
/ National Sculpture Factory, Cork)

'In a journey through three resonant spaces in Cork
city, an event will unfold as a serial experience of
psychological intensity. As with a collection of
poems, each will be complete but will also
contribute to a cumulative experience that will
continue to evolve over time. It is a landscape of loss
and yearning, of faded glamour and improvised
survival.'

— programme notes

'Over the first year Johnny Hanrahan and Daphne
Wright evolved the concepts through drawings. The
second year, definitions of art and theatre inevitably
collided. The multi-authored world of theatre
contrasts with solo-authored visual art practise ...
Croon is bravely interdisciplinary rather than
multidisciplinary, surpassing the familiar yardsticks.'

— Niamh Lawlor, *Circa*

The project was nominated for the innovation award
in the Irish Times Theatre Awards, 2005.

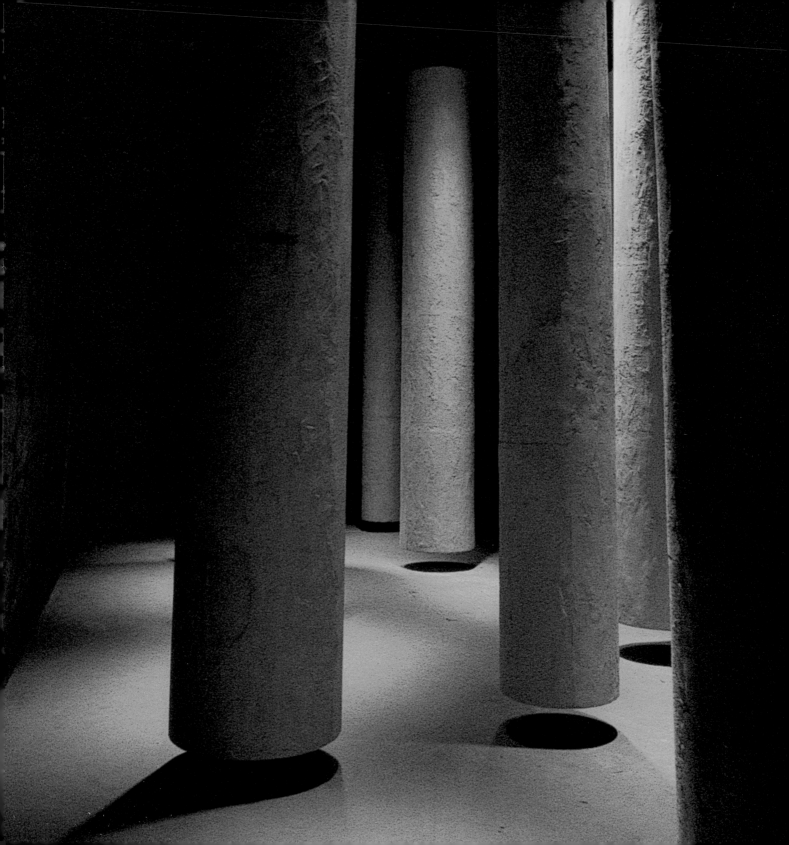

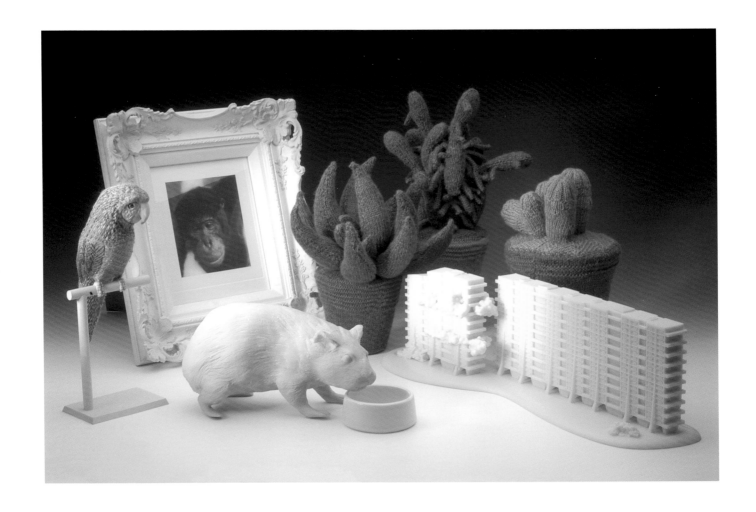

Home Ornaments
2002-05, fastcast polyurethane

The *Home Ornaments* editions were made as a special commission to mark the building/rebuilding of the Gorbals, Glasgow, 1998-2005. The commission was organised by Artworks Project, in association with CZWG Architects.

continued from page 24

portraits of bulls, a film of cattle in an enclosure, casts of two different stillborn calves and of a bull's severed head.

Imagery from the natural world abounds in Wright's practice. In the case of *Domestic Shrubbery* both the woman's cuckoo call and the rendering of a floral motif seems pointed, evoking a mindset that likes to see nature and people under controlled and safe circumstances, deprived of life, of any ability to surprise or disappoint. Other natures that have been depicted include orchards, trees, birds – the aforementioned cuckoos and herons, as well as seagulls and songbirds – flowering vines, greenhouses, cliffs, and the list could go on. Cultivated and wild nature are all frequently represented as something static, fossilised, deathly even, often deprived of majesty and a purposefulness independent of human action. Hence, they are denied a level of inscrutability by their absurd, useless or grotesque rendering. There are metallic succulents, fantastic trees that can never grow or die, branches bent by a ridiculous, exaggerated yield, vines stifled by blood-red lacquer, and birds destined to be eternally dead without dignity – a fate reminiscent of the original strange fruit. *Sires* presents the most recent development in Wright's engagement with nature; it is, on the face of it, a reflection upon the bull.

The bull is a creature overladen with legend, with a sexual potency elevated to mythic proportions He represents power and a brute magnificence. At the centre of many founding Greek myths is the figure of the bull: Zeus's abduction and rape of Europa in the guise of a splendid golden-white bull; Pasiphaë enraptured by the dazzling white bull of Poseidon's sea; Theseus' murder of their offspring the Minotaur. The slaughter of a bull was the greatest, most intoxicating sacrifice that could be offered to the Gods.

It could be argued that the centrepiece of Wright's show was *Death Mask, Horace, 14 June 2003*. A real bull's severed head is cast in white painted plaster, his huge tongue lolls from his mouth, and the hide and flesh of his throat are cleft. The fineness of the casting captures every detail – the texture of his coat, the exposed meat and sinew of his neck, and the slight wrinkles in the skin about his ears. We could easily understand

this record as the end of something inhuman and powerful, a majestic progenitor. This anthropomorphic gesture. This metamorphosis of the dead bull into a human artefact could be read as a flawed tribute, a foolish attempt to describe nature in man's image. However, though the face of this individual bull may be recorded for posterity, he has no history to mark him as deserving of this act of remembrance; nobody but perhaps a handful of farmers could ever recognise him or know his true worth. Even at that, though respect for and great pride in a fine animal may be important, lavish sentiment for animals is not generally afforded by the farming community. *Death Mask, Horace, 14 June 2003* lacks the fundamental composure and dignity of a death mask – the final portrait of the great or good. The wound in the bull's neck, the distended tongue and matted coat bespeaks his violent end, or at least the violence done unto him after death. The death mask normally records a face; this is a whole, gorily severed head. Beheading is the fate of the despised, or, at best, the martyr; it is an ignoble end.

Wright displays the unfortunate beast on the floor – a further abasement of any perceived dignity. The hollowed cast is lustrous, blank, cool and white. The transformation of brawn and raw viscera into hard, shiny plaster seems a typical Wright manoeuvre – an act of distancing, of ossification. The horror, the indignation, the potential disgust of the viewer is deferred; it may unfold in one's mind, but the head itself is objectified, aestheticised. Horace is sanitised, rendered safe, made interesting and beautiful, turned somehow into a negative space – a blank slate or an absence, superficially possessed of an animal's appearance but not its animating spirit or attributes.

The bull was so esteemed in sacrificial tradition not only because it was a fearsome creature, but because it had economic worth. From a purely human perspective. Wright has taken Horace, once a working, fertile animal, removed (part of) him from the life/food chain that was his lot, and made of his head something senseless with only a dubious shroud of high culture to validate it. That Wright has chosen to cast the real bull seems to be an unprecedented use in her practice of primary natural material. This is not an ur-bull of the same order as her trees or cliffs which are intelligible as schemas or emblems of tree-ness or cliff-ness. Nor is it nature at a remove, a cast of a man-made pattern, be it wallpaper or wrought iron. Like a photograph, the cast cannot escape its referent in the real world. Horace is still, however, an abstraction.

The other works in the *Sires* series are similarly decontextualised and sublimated. The vivid intaglio prints made from photographs are so highly contrasted, so textured, it takes several moments to read them as bulls' faces. They seem of the tradition of animal portraits until you realise that they don't display the animal in any usefully recognisable way; the prints don't capture the physical characteristics of a superb specimen. That the bulls have names – Joe, Reuben, Luke and George – is indicative of their individualisation, the esteem in which they are held, apparently unlike numbered cows. Wright's representation of them is so formal, again, so aestheticised it makes them virtually anonymous.

Throughout the show she employs again the tactic of glossing the commonplace, seeming to make it beautiful, more engaging, but actually making it more distant. The more beautiful the rendering, the further we get from any sense of a real, individual bull. Even the exquisite casts of the two different stillborn calves are unemotional. That is not to say they are not evocative, but they are cool and clinical records, devoid of vulnerability, of impenetrable animal qualities. It is somewhat sad to see them cast thus, both mouths slightly ajar, tongues poking out, a shame to think of the cows' futile labours and a farmer's disappointment, but hard to know what to make of that sorrow, of their representation. Both the perfectly formed delicate stillborn and the thick-limbed misshapen brute are piteous creatures, but they are clearly of a different order. Their absence of life, like the death of the bull, does not ask or need our sentiment, remembrance or care. They signal on some level simply an unfulfilled potential, agricultural waste, and, therefore, they 'naturally' remain, unlike a stillborn human baby, unnamed.

The show *Sires* perhaps reminds us that nowadays (in a time of widespread visceral insulation) this is how we need to see these animals in order to live off them. We need to see their carcasses

as abstract, cleansed of dirt, devoid of life or individuality. Alongside the three desolate, displaced casts and the 'glamour shots' of the living studs, Wright exhibited a film. *Sires* is a continuous loop showing the lower legs and hoofs of many cattle held in a pen. It is, of course, beautifully filmed in rich colour, it is almost mesmeric, and just the right length to compel your full attention. These beasts are very much alive, bellowing and shifting about. The soundtrack reaches a crescendo with the combined noises of mooing, jets of piss, spattering shit and the slapping of hooves in mud. The noise gives way to near silence, and the movement of restless legs cuts to a close up of hooves, toes squelching and flexing in the messy slop of excreta and mud. To a small degree the close attention makes them remarkable, as commonplace or overlooked entities often become under fresh scrutiny. Nevertheless, these are real farmed animals – not unique, but anonymous and numerous. Clearly this is not a sleek filmic monument to lost potency, rather these undifferentiated cattle (cows?) are livestock who will survive until is profitable for them to be dead. They will be consumed, not remembered.

Wright seems always to be asking us to get beyond our disconnectedness or any narrow anthropocentric focus, but she doesn't do this by making judgements or pronouncements, or by offering succour, or winning, easy beauty. There is a cerebral distance and a pragmatism that won't suffer fools or sentiment which permeates much of her practice. The humour of earlier work seems, in recent years, to have been set aside in favour of a greater coldness and obliqueness. Wright presents us with works that simultaneously alienate us and demand our attention, our curiosity – they sulk and we cannot ignore. They are works that require us to determine how we stand in relation to them, and to the world we inhabit.

Even when the sun shines and the tide is nearly in, Dublin's Sandymount Strand is often empty. Hemmed in at the north end by an industrial horizon line, it is quiet, uninteresting, but has a scruffy, if bleak charm. The clouded sea glitters only when at a great distance. To the south and east the sky is big and uninterrupted. The distractions and joys of perfect sandy beaches and dunes, or the awesome beauty of waves crashing against cliffs seem very far from its open, flat expanse. A friend once noted that it was a difficult place to get lost in a romantic or metaphysical reverie because at any moment you might stand in dog shit. Somehow this mundane-ness seems more 'real', a more concrete situation in which to think about your own feelings – your predictably wonderful or awful experiences – than somewhere overwhelmingly beautiful. In any case, a pair of herons might come into view, and, though ordinary, there is something special, something unfathomable about their presence, and it's enough to remind you that the commonplace doesn't need to be made exotic to be remarkable, and that the empty, cold, uncomfortable spaces demand and deserve our careful attention.

Wright is, I suspect an artist who expects us to make meaning of life's raw experiences, to not ignore heartache and loneliness. Hers is not the kind of artwork that comes to fruition with the engagement of the viewer; rather, I think of Wright's work as making us labour to feel human in its presence.

Isabel Nolan is an artist and writer based in Dublin. Recent exhibitions include *Ireland at Venice*, 2005, and *Everything I said let me explain*, a solo show at the Project Arts Centre, Dublin, 2005.

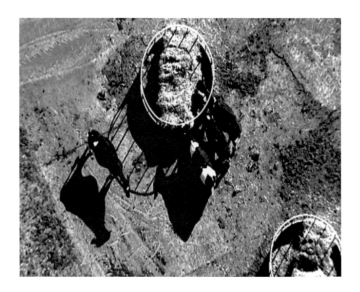

A Hundred Weight
2005, DVD, 3 min loop

sound: spoken phrases from *The Man Comes Around*
(Johnny Cash, © 2003 American Recordings)
(film-maker: DW; camera: Polo Aviation, Bristol)

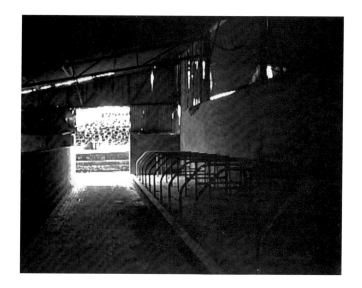

Someone who is there
2005, DVD, 3 min loop

sound: spoken phrases from *The Man Comes Around*
(Johnny Cash, © 2003 American Recordings)
(film-maker: DW; camera: Seamus Grogan)

LIST OF ILLUSTRATIONS

44-47　*Indeed Indeed*
1998, tin foil, glue and continuous loop tape, dimensions variable
but highest point 366cm　　　　　　　　　　　　　　　　　　(Peter Sorg)

48-49　*Nonsense and Death*
1998, tin foil, wire, paint and continuous loop tape, 274 x 264 cm
　　　　　　　　　　　(main – Stephen White; details – Peter Sorg, Ronan MacEvilly)

50-53　*Where do broken hearts go?*
2000, cacti, tin foil, glue, resin and continuous loop tape, plus a series of 9 continuous-
tone photopolymer intaglio plates, highest cacti: 381 cm; prints: 29 x 39 cm (ed. 4)
　　　　　　　　　　　　　　　　　　　　(Denis Mortell, Richard Robinson)

54-57　*These Talking Walls*
2001, 2 space capsules (tin foil and fibreglass) and continuous loop tape,
and a series of 4 photopolymer intaglio plates, 137 x 122 cm (ed. 4)　　　(Richard Robinson)

58　*Bulls – Luke*
2002, polymer intaglio print, 53 x 63 cm (ed. 5)

59　*Bulls – Joe*
2002, polymer intaglio print, 65 x 51 cm (ed. 5)

60　*Bulls – Reuben*
2002, polymer intaglio print, 65 x 51 cm (ed. 5)

61　*Bulls – George*
2002, polymer intaglio print, 53 x 63 cm (ed. 5)

62　*Stillborn*
2003, chalk resin, 102 x 63 x 13 cm (ed. 2)

63　*Death Mask, Horace, 14 June 2003*
2003, painted plaster, 104 x 76 x 60 cm

64　*Stillborn, The Brute*
2003, chalk resin, 102 x 63 x 13 cm (ed. 2)

65　*Sires*
2003, DVD loop, 3 mins　　　　　　　(film-maker: DW; camera: Mino de Francesca)

66-71　*Croon*
2004, collaboration between Daphne Wright and Johnny Hanrahan
　　　　　　　　　　　　(Dara McGrath, courtesy National Sculpture Factory)

72　*Home Ornaments*
2002-05, fastcast polyurethane

76　*A Hundred Weight*
2005, DVD, 3 min loop　　　　　　　(film-maker: DW; camera: Polo Aviation, Bristol)

77　*Someone who is there*
2005, DVD, 3 min loop　　　　　　　(film-maker: DW; camera: Seamus Grogan)

Unless otherwise stated, illustrations courtesy of the artist and Frith Street Gallery, London)

DAPHNE WRIGHT

1963	Born in Co Longford
1981-85	Sligo Regional Technical College
1985-87	National College of Art & Design, Dublin
1989-91	Newcastle-upon-Tyne Polytechnic
1991-92	Fellowship, Cheltenham and Glouster College of Art
1992-93	British School at Rome
1993-94	Henry Moore Fellowship, Manchester Metropolitan University
	Lives and works in Bristol

Solo Exhibitions

2006	*Daphne Wright*, Limerick City Gallery of Art
2005	*One Hundred Weight*, Sligo Art Gallery
	Sires, Éigse, Carlow Arts Festival
2003	*Sires*, Frith Street Gallery, London
	Anonymous, University of Essex Gallery
	These Talking Walls, Crawford Gallery, Cork
2002	*Shine – These Talking Walls*, Lowry Centre, Salford
2001	*These Talking Walls*, New Art Centre Sculpture Park and Gallery, Roche Court, Salisbury, Wiltshire
	Nonsense and Death, Sligo Art Gallery
2000	*Where do broken hearts go?*, Douglas Hyde Gallery, Dublin
1998	*They've taken to their beds*, Spacex Gallery, Exeter; Temple Bar Gallery, Dublin; Limerick City Gallery
	New Work, Aspex Gallery, Portsmouth
	New Works, Frith Street Gallery, London
1996	*Lots Wife 2*, London Artforms, London
1995	*Domestic Shrubbery*, Castlefield, Manchester
1994	*Still Life*, Cornerhouse, Manchester
	Domestic Shrubbery, Model Arts Centre, Sligo; Limerick City Gallery of Art

Commissions

2005-06	*The Listening Posts*, sculpture installation, Penrose Quay, Cork
2004-05	*The Witness Tree*, sculpture installation, Castlebar Courthouse, Co Mayo
2002-05	*Home Ornaments,* Gorbals, Glasgow (in association with CWZG Architects and the Artworks Programme)
2002-03	Ballymun Project, Dublin (in association with BDP and Breaking Ground)
1999	Tron Project, Glasgow (in association RMJM and Visual Art Projects)

Group Exhibitions

2005	*Sculpture at Kells*, Mullins Mill, Kells, Co Kilkenny
	Ystrad Fflur/Strata Florida, Ceredigion, Wales
	New Sculpture from Ireland, New Art Centre Sculpture Park and Gallery, Roche Court, Salisbury
2004	*Croon* (in collaboration with Johnny Hanrahan) (presented by Meridian Theatre Company / National Sculpture Factory, Cork)
	After Life, Bowes Museum, Co Durham
2003	*Sculpture: A Spectator Sport*, Bryanston Park, Hampshire
2002	*A Pause for a Breath*, Frith Street Gallery, London
	Locws International 2002, site-specific art events, Swansea
2001	*The Garden*, Model Arts & Niland Gallery, Sligo
2000	*From a Distance: Approaching Landscape*, Institute of Contemporary Art, Boston
1999	*0044 – Irish Artists in Britain*, PS1 Contemporary Art

Center, New York; Albright Knox Museum, Buffalo; Crawford Municipal Art Gallery, Cork

1998-99 *Book*, Djanogly Art Gallery, University of Nottigham; Aberystwyth Arts Centre, Wales; Oriel Mostyn, Llandudno, Wales

Delectable, Real Gallery, New York

Eastenders, site-specific art event, Manchester

EV+A 98 – circus zz, Limerick (invited artist)

1997 *A Case for Collection – New Work by Contemporary Artists*, Towner Gallery, Eastbourne

Earthly Delights, Ikon Gallery, Birmingham, and touring

Irish Geographies, Djanogly Art Gallery, Nottingham, and touring

Critic's Choice, RHA Gallagher Gallery, Dublin

1996 *Private View*, Bowes Museum, Co Durham

Summer Show, Kerlin Gallery, Dublin

1995 *On Stream*, Bluecoat Gallery, Liverpool

Clot, London Artforms, London

Making It, Tate Gallery, Liverpool

1993 *Full Circle*, British School at Rome

Arte e Altro – Giovani Artisti 5, Territoria, Sala 1, Rome

1992 Cheltenham Fellows Show, Pittville Gallery, Cheltenham

1991 *The Gymnasium*, Goldsmith's College, London

Selected Bibliography

2006 John O'Regan (ed.), *Profile 23 – Daphne Wright* (Gandon Editions, Kinsale)

Home Ornaments, essay by Francis McKee & Simon Morrissey (forthcoming)

2004 *After Life*, essay Simon Morrissey (Bowes Museum, Co Durham)

2003 *Anonymous*, essays by Edwina Ashton and David Jeffreys (University of Essex Gallery

2002 *Locws International 2002*, essay by Emma Safe (Swansea Museum, Wales)

Shine – Theses Talking Walls (Lowry Centre, Salford)

2001 *Where do broken hearts go?*, essays by Juliana Engberg and John Hutchinson (Douglas Hyde Gallery, Dublin)

Patmos, essay by John Hutchinson (Douglas Hyde Gallery, Dublin)

1999 Peter Murray (ed.), *0044 – Irish Artists in Britain*, interview with Daphne Wright by Vera Ryan (Crawford Gallery, Cork / Gandon Editions, Kinsale)

View, essays by Sarah Shalgosky and Annabel Longbourne (Mead Gallery, Coventry)

1998 *Book*, essays by David Bickerstaff and Paul Bonaventura (Djanogly Art Gallery, Nottingham)

They've taken to their beds, essays by Fiona Bradley, Shirley MacWilliam, Mebh Ruane and Rob Stone, (Spacex Gallery, Exeter)

1997 Catherine Nash (ed.), *Irish Geographies* (Djanogly Art Gallery, Nottingham)

1996 *Private View*, essays by Penelope Curtis and Viet Gorner (Bowes Museum, Co Durham)

1995 *Making It*, essay by Fiona Bradley (Tate Gallery, Liverpool)

1994 *Works by Daphne Wright 1991-1994*, essays by Fionna Barber and Shirley MacWilliam (Manchester Metropolitan University)

Versus Contemporary Art Magazine, Artist page no.3

Orange, in conversation with Sasha Craddock (Manchester Metropolitan University)

1993 *Territoria*, essays by Francesca Capriccioli and Alessandra Cappella (Sala 1, Rome)

Full Circle, essay by Jon Thompson (British School at Rome)

Public collections include the Irish Museum of Modern Art, Dublin; Towner Art Gallery, Sussex (purchased through CASC and Arts Council of England)

Daphne Wright is represented by Frith Street Gallery, 59-60 Frith Street, London, W1D 3JJ – t: +44 (0)20 7494 1550 f: +44 (0)20 7287 3733 / www.frithstreetgallery.com

GANDON EDITIONS

Gandon Editions is the leading producer of books on Irish art and architecture. Established in 1983, it was named after the architect James Gandon (1743-1823) as the initial focus was on architecture titles. We now produce 20 art and architecture titles per year, both under the Gandon imprint and on behalf of a wide range of art and architectural institutions in Ireland. We have produced 300 titles to date. Gandon books are available from good bookshops in Ireland and abroad, or direct from Gandon Editions.

PROFILES

In 1996, Gandon Editions launched PROFILES – a series of medium-format books on contemporary Irish artists. In 1997, we launched ARCHITECTURE PROFILES – a companion series on contemporary Irish architects. Both series are edited and designed by John O'Regan.

Each volume in the PROFILES series carries at least two major texts – a critical essay and an interview with the artist or architect – and is comprehensively illustrated in colour. In response to demand from readers, we have expanded the pagination and colour content of both series, reinforcing the two PROFILES series as the key reference series on contemporary Irish artists and architects.

ART PROFILES

Profile 1 – PAULINE FLYNN
essays by Paul M O'Reilly and Gus Gibney
ISBN 0946641 722 Gandon Editions, 1996
48 pages 22 illus (incl 19 col) €10 pb

Profile 2 – SEÁN McSWEENEY
essay by Brian Fallon; interview by Aidan Dunne
ISBN 0946641 862 Gandon, Spring 2005
(2nd revised and expanded ed; 1st ed, 1996)
60 pages col illus €10 pb

Profile 3 – EILÍS O'CONNELL
essay by Caoimhín Mac Giolla Léith; interview by Medb Ruane
ISBN 0946641 870 Gandon Editions, 1997
48 pages 35 illus (incl 27 col) €10 pb

Profile 4 – SIOBÁN PIERCY
essay by Aidan Dunne; interview by Vera Ryan
ISBN 0946641 900 Gandon Editions, 1997
48 pages 38 illus (incl 32 col) €10 pb

Profile 5 – MARY LOHAN
essay by Noel Sheridan; intro and interview by Aidan Dunne
ISBN 0946641 889 Gandon Editions, 1998
48 pages 22 illus (incl 21 col) €10 pb

Profile 6 – ALICE MAHER
essay and interview by Medb Ruane
ISBN 0946641 935 Gandon Editions, 1998
48 pages 29 illus (incl 23 col) €10 pb

Profile 7 – CHARLES HARPER
essay by Gerry Walker; interview by Aidan Dunne; afterword by Bob Baker
ISBN 0946846 111 Gandon Editions, 1998
48 pages 24 illus (incl 19 col) €10 pb

Profile 8 – MAUD COTTER
essay and interview by Luke Clancy
ISBN 0946846 073 Gandon Editions, 1998
48 pages 30 illus (incl 24 col) €10 pb

Profile 9 – MICHEAL FARRELL
essay by Aidan Dunne; intro and interview by Gerry Walker
ISBN 0946846 138 Gandon Editions, 1998
48 pages 33 illus (incl 25 col) €10 pb

Profile 10 – BARRIE COOKE
intro by Seamus Heaney; essay by Aidan Dunne; interview by Niall MacMonagle
ISBN 0946846 170 Gandon Editions, 1998
48 pages 29 illus (incl 25 col) €10 pb

Profile 11 – VIVIENNE ROCHE
essay by Ciarán Benson; intro and interview by Aidan Dunne
ISBN 0946846 235 Gandon Editions, 1999
48 pages 39 illus (incl 30 col) €10 pb

Profile 12 – JAMES SCANLON
essay by Aidan Dunne; interview by Shane O'Toole; afterword by Mark Patrick Hederman
ISBN 0946641 579 Gandon Editions, 2000
48 pages 51 illus (incl 37 col) €10 pb

Profile 13 – TONY O'MALLEY
essay by Peter Murray; intros by Jay Gates, Jean Kennedy Smith
ISBN 0946846 456 Gandon Editions, 2000
48 pages 30 illus (incl 26 col) €10 pb

Profile 14 – ANDREW KEARNEY
essay by Simon Ofield; interview by Aoife Mac Namara; intro by Mike Fitzpatrick
ISBN 0946846 74X Gandon Editions, 2001
60 pages 83 illus (incl 69 col) €10 pb

Profile 15 – BERNADETTE KIELY
essay by Aidan Dunne; interview by Jo Allen; afterword by Ciarán Benson
ISBN 0946846 804 Gandon Editions, 2002
60 pages 41 illus (incl 35 col) €10 pb

Profile 16 – ANNE MADDEN
essay and interview by Aidan Dunne
ISBN 0946846 863 Gandon Editions, 2002
60 pages 42 illus (incl 37 col) €10 pb

Profile 17 – ANDREW FOLAN
essay by Paul O'Brien; intro and interview by Patrick T Murphy
ISBN 0946641 919 Gandon Editions, 2002
60 pages 57 illus (incl 46 col) €10 pb

Profile 18 – JOHN SHINNORS
essay by Brian Fallon; intro and interview by
Aidan Dunne
ISBN 0946846 782 Gandon Editions, 2002
60 pages 51 illus (incl 49 col) €10 pb

Profile 19 – JACK DONOVAN
essays by Gerry Dukes, Aidan Dunne, John
Shinnors; interview by Mike Fitzpatrick
ISBN 0946846 200 Gandon Editions, 2004
84 pages 90 illus (incl 71 col) €15 pb
*(also available in a clothbound edition from
Limerick City Gallery of Art, entitled* Jack
Donovan – Paintings 1959-2004,
ISBN 09544291 33, €25 hb)

Profile 20 – TOM FITZGERALD
essays by Suzanne O'Shea, Seán Ó Laoire;
interview by Jim Savage
ISBN 0946846 618 Gandon Editions, 2004
84 pages 92 illus (incl 75 col) €15 pb
*(also available in a clothbound edition from
LCGA, entitled* Tom Fitzgerald – The Ministry of
Dust, *ISBN 09544291 41, €25 hb)*

Profile 21 – AMANDA COOGAN
essays by Caoimhín Mac Giolla Léith, Apinan
Poshyananda; interview by Mike Fitzpatrick;
intro by Marina Abramovic
ISBN 0948037 172 Gandon Editions, 2005
72 pages 92 illus (incl 85 col) €15 pb
*(also available in a clothbound edition from
LCGA, entitled* Amanda Coogan – A brick in the
handbag, *ISBN 09544291 68, €25 hb)*

Profile 22 – DONALD TESKEY
essays by Frank McGuinness, Aidan Dunne;
interview by Mike Fitzpatrick
ISBN 0948037 245 Gandon Editions, 2005
108 pages 119 illus (incl 100 col) €20 pb
*(also available in a clothbound edition from
LCGA, entitled* Donald Teskey – Tidal Narratives,
ISBN 09544291 84, €30 hb)

Profile 23 – DAPHNE WRIGHT
essays by Penelope Curtis, Isabel Nolan;
interview by Simon Morrrissey
ISBN 0948037 261 Gandon Editions, 2006
84 pages 96 illus (incl 63 col) €15 pb

ARCHITECTURE PROFILES

Profile 1 – O'DONNELL + TUOMEY
interview by Kester Rattenbury; texts by Hugh
Campbell, Kevin Kieran, Robert Maxwell, Wilfried
Wang, Williams & Tsien
ISBN 0946641 986 Gandon Editions, 1997
48 pages 64 illus (incl 27 col) €10 pb

Profile 2 – McGARRY NÍÉANAIGH
essay by Raymund Ryan; interview by
Dermot Boyd
ISBN 0946641 994 Gandon Editions, 1997
48 pages 56 illus (incl 26 col) €10 pb

Profile 3 – GRAFTON ARCHITECTS
essays by Hugh Campbell, Kenneth Frampton,
Elizabeth Hatz; interview by Raymund Ryan
ISBN 0946846 057 Gandon Editions, 1999
60 pages 131 illus (incl 86 col) €10 pb

Profile 4 – SHAY CLEARY
essay by Raymund Ryan; interview by Simon
Walker; afterword by Edward Jones
ISBN 0946846 898 Gandon Editions, 2002
132 pages full-colour 320 illus €20 pb

titles in preparation
Louis LE BROCQUY
Michael CULLEN
Paul DORAN
Camille SOUTER

ORDER FORM

These books can be ordered from any good
bookshop or direct from Gandon Editions
(same-day dispatch; postage free in Ireland;
elsewhere at cost). Please indicate quantities
required alongside volume numbers below:

ART PROFILES
___1 ___2 ___3 ___4 ___5
___6 ___7 ___8 ___9 ___10
___11 ___12 ___13 ___14 ___15
___16 ___17 ___18 ___19 ___20
___21 ___22 ___23
____ forthcoming: _____
____ _____

ART PROFILES clothbound editions
____19 ____20 ____21 ____22

ARCHITECTURE PROFILES
____1 ____2 ____3 ____4

■ PAYMENT – You can order by phone,
fax, e-mail or post ... and pay by credit card or
by € euro / £ stg / $ US dollar cheque.
❏ cheque enclosed € / £ / $ _____
❏ charge to Laser / Mastercard / Visa a/c MasterCard VISA

___ ___ ___ ___

___ ___ ___ ___

expiry date ___ ___ / ___ ___ security code ___ ___ ___

name _____
 PRINT NAME & ADDRESS
address _____

TRADE: order # _____ S/R; usual terms apply

GANDON EDITIONS
Oysterhaven, Kinsale, Co Cork, Ireland
T +353 (0)21-4770830 / F 021-4770755
E gandon@eircom.net 1/06